Contents

Introduction Page 7
Some Known Dates in Titian's Life 27
Notes on the Illustrations 28

BLACK AND WHITE ILLUSTRATIONS
 1 Self-portrait (frontispiece)
 2 Bellini: Madonna and Child with Saints 8
 3 Bellini: Agony in the Garden 10
 4 Giorgione: Madonna and Child with Saints 12
 5 Titian: St Mark with other Saints 13
 6 Bellini and Titian: The Feast of the Gods 15
 7 Veronese: The Marriage of St Catherine 16
 8 Rota: The Death of St Peter Martyr (engraving) 17
 9 Donatello: St Anthony and the Youth's Leg 18-19
10 Giorgione: Sunset Landscape 21
11 Titian: Charles V at Mühlberg 23
12 Giorgione: Venus 25
13 Giorgione: Le Concert Champêtre 26

THE COLOUR PLATES
 1 Pope Alexander VI presents Jacopo Pesaro
 2 St Anthony Healing the Youth's Leg
 3 Three Ages of Man
 4 The Baptism of Christ
 5 Noli me Tangere
 6 Sacred and Profane Love
 7 Sacred and Profane Love (detail)
 8 Sacred and Profane Love (detail)
 9 The Gipsy Madonna
10 Madonna with the Cherries
11 The Assumption of the Virgin
12 The Assumption of the Virgin (detail)
13 The Madonna of the Pesaro Family
14 St Sebastian
15 Bacchanal of the Andrians
16 Bacchus and Ariadne

17 The Entombment of Christ
18 Venus of Urbino
19 Portrait of a Venetian Gentleman
20 Portrait of a Man
21 Portrait of a Young Man
22 Portrait of a Young Man
23 Pietro Aretino
24 The Vendramin Family
25 The Presentation of the Virgin
26 The Presentation of the Virgin (detail)
27 Pope Paul III
28 Pope Paul III and his 'Nipoti'
29 Philip II
30 La Gloria
31 La Gloria (detail)
32 La Gloria (detail)
33 Ecce Homo
34 Ecce Homo (detail)
35 Ecce Homo (detail)
36 St Jerome
37 Christ Crowned with Thorns
38 Danäe
39 Venus and Adonis
40 Diana and Actaeon
41 Diana and Actaeon (detail)
42 Diana and Callisto
43 Diana and Callisto (detail)
44 The Rape of Europa
45 The Rape of Lucretia
46 The Education of Cupid
47 Numph and Shepherd
48 The Entombment of Christ
49 Annunciation
50 Christ Crowned with Thorns
51 Portrait of Jacopo Strada
52 Pietà

Titian

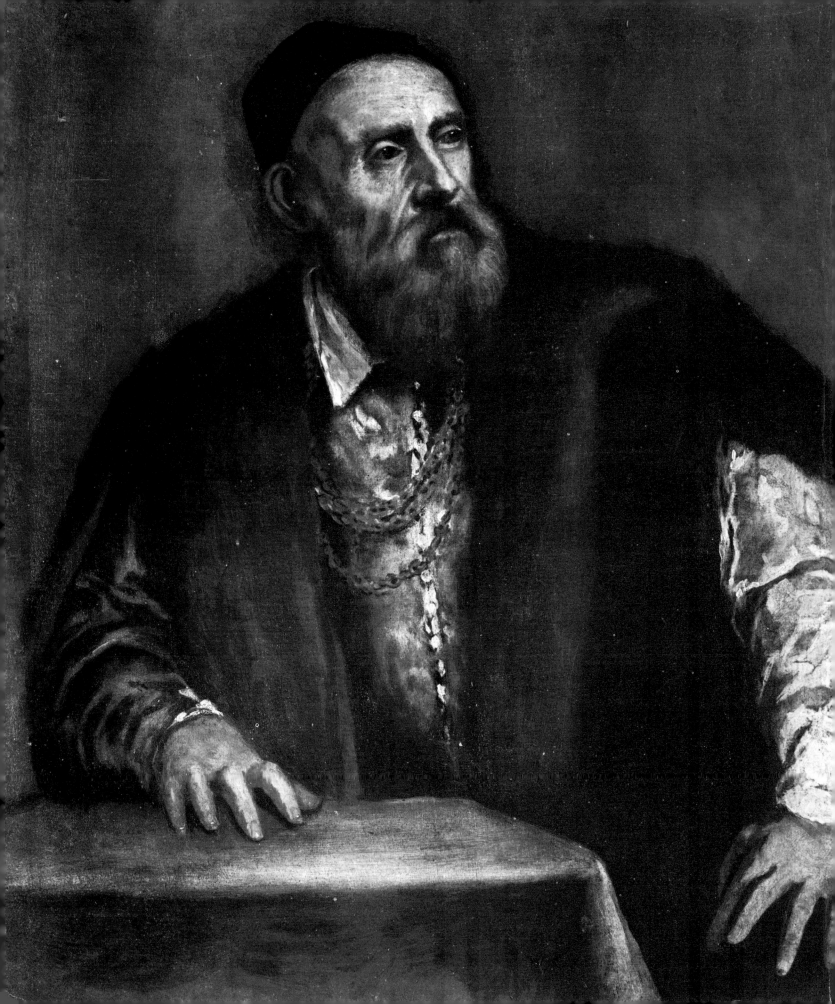

Cecil Gould

Titian

The Colour Library of Art

Hamlyn

London · New York · Sydney · Toronto

Acknowledgments

The paintings in this volume are reproduced by kind permission of the following churches, collections, museums and galleries to which they belong: Accademia, Venice (Plates 25, 26, 52, Figure 7); Alte Pinakothek, Munich (Plate 50); Brera, Milan (Plate 36); Trustees of the British Museum, London (Figure 8); Capodimonte, Naples (Plates 27, 28); Cathedral, Castelfranco (Figure 4); Church of the Frari, Venice (Plates 11, 12, 13); Church of SS Nazaro and Celso, Brescia (Plate 14); Church of San Salvadore, Venice (Plate 49); Church of St Zaccaria, Venice (Figure 2); Syndics of the Fitzwilliam Museum, Cambridge (Plate 45); Frick Collection, New York (Plate 23); Isabella Stewart Gardner Museum, Boston (Plate 44); Gemälde-galerie, Berlin-Dahlem (Figure 1); Gemäldegalerie, Dresden (Figure 12); Earl of Halifax, Garrowby Hall (Plate 21); Kunsthistorisches Museum, Vienna (Plates 9, 10, 33, 34, 35, 47, 51); Louvre, Paris (Plates 17, 37, Figure 13); Musée Royal des Beaux-Arts, Antwerp (Plate 1); Trustees of the National Gallery, London (Plates 5, 16, 20, 24, Figures 3, 10); National Gallery of Art, Washington D.C., Samuel H. Kress Collection (Plate 19); National Gallery of Art, Washington D.C., Widener Collection (Figure 6); Palazzo Pitti, Florence (Plate 22); Pinacoteca Capitolina, Rome (Plate 4); Prado, Madrid (Plates 15, 29, 30, 31, 32, 38, 39, 48, Figure 11); Church of the Santo, Padua (Plate 2, Figure 9); Duke of Sutherland Collection, on loan to the National Gallery of Scotland, Edinburgh (Plates 3, 40, 41, 42, 43); Uffizi, Florence (Plate 18); Villa Borghese, Rome (Plates 6, 7, 8, 46). The following photographs were supplied by Alinari, Florence (Plates 6, 11, 25, Figures 2, 4, 7, 9); Joachim Blauel, Munich (Plate 50); Harold Bridge, York (Plate 21); Deutsche Fotothek, Dresden (Figure 12); Giraudon, Paris (Figure 13); Mauro Pucciarelli, Rome (Plates 4, 46); Scala, Florence (Plates 2, 7, 8, 12, 13, 14, 15, 18, 22, 26, 27, 28, 29, 30, 31, 32, 38, 39, 49, 52); Tom Scott, Edinburgh (Plates 3, 40, 41, 42, 43).

Frontispiece: Self-portrait *c.* 1550. Germäldegalerie, Berlin-Dahlem.

Frontispiece: Self-portrait *c.* 1550
Gemäldegalerie, Berlin – Dahlem

Published by
THE HAMLYN PUBLISHING GROUP LIMITED
London · New York · Sydney · Toronto
Hamlyn House, Feltham, Middlesex, England

ISBN 0 600 38651 1

Printed in Italy by Officine Grafiche Arnoldo Mondadori, Verona

Introduction

The painter Titian is so famous in English-speaking countries, and has always been so famous, that we may forget that such was not his name, and that it is merely an anglicised version of Tiziano. This principle, indeed, is common enough in reverse. For example, the Italians turn the Christian names of Johann Sebastian Bach into 'Giovanni Sebastiano', thereby even changing one of his initials, and 'Giorgio Bernardo Shaw' is also normal. The French, too, transform Pope Pius (in Italian 'Pio') into 'Pie' and Livy into 'Tite Live'. But in England such chauvinism is rarer. We do not call the painter of the Mona Lisa 'Leonard', and though 'Paul' Veronese, 'John' Bellini and 'Tintoret' were used by Ruskin they are used no longer. Titian and Raphael (Raffaello) are in fact probably the only Italians (if we except 'Michael' Angelo, which is so near the original as not to count) whose names have been consistently anglicised, and this is no accident as their fame in this country has never been eclipsed.

Since different ages admire different qualities it would follow that any creative genius who has been uninterruptedly admired for many centuries must have been sufficiently many-sided to mean different things to different men. With Shakespeare, for instance, this has been the case. What Dryden saw in him, or Dr Johnson, or Henry Irving, is different from what we see. And though Titian was long admired primarily as the supreme colourist and secondarily as one of the greatest portraitists, the admiration of the 20th century has been less restricted. Writing, indeed, just before 1900, Bernard Berenson said: 'Titian . . . is the only painter who expressed nearly all of the Renaissance that could find expression in painting'. More recently art historians have been interested in him as a pioneer of landscape painting, and have also been showing more than a passing interest in the significance of his career in the social scene. Partly through the help which he had from Pietro Aretino, Titian, together with Raphael at the end of his short life, and Michelangelo, raised the status of the artist from near the bottom of the social ladder to near the top. From being a mere craftsman he was now – at least in the person of these three – a purveyor of goods for which the crowned heads of Europe competed. And since the demand enormously exceeded the supply the artist was, on occasion, able – indeed, forced – to turn a deaf ear to the blandishments of the mighty and ignore their requests.

Successive generations without exception have been in-trigued by the question of Titian's age – traditionally ninety-nine at the time of his death. But extreme longevity has an intrinsic fascination which need not be connected with talent. Michelangelo may have achieved eighty-nine (he did), and Wren ninety. Fontanelle may even, as incontrovertibly, have approached within weeks of his hundredth birthday. In this context posterity is just as interested in Old Parr or the Countess of Desmond, who had otherwise nothing to offer. In Titian's case, though, there is the extra titillation of uncertainty. He was undoubtedly very old indeed when he died, but we do not know how old. The evidence is conflicting, and there can be no doubt that, like other very old people whose age has become legendary within their life-time, Titian himself exaggerated it. All we can say with certainty is that his active career as a painter spanned not less than about seventy years – from a few years before 1511 until his death in 1576. At the time of his death he cannot have been less than in his upper eighties and may easily have been older. More than this we cannot say.

But there is another, and more interesting way of regarding Titian's longevity. Like Louis XIV, or Pope Pius IX, both of whose reigns were not only in themselves the longest on record but happened in each case to be followed by the second longest (Louis XV and Leo XIII respectively) so Titian's extended marathon was juxtaposed with another only slightly less long. This one preceded his, instead of following it. One of his masters, Giovanni Bellini, was himself a considerable but un-defined age when he died, still almost at the height of his powers, in 1516. His career and Titian's – the two greatest Venetian painters – thus span well over a century, and therefore, in effect, smoothed the transitions of style at Venice far more gradually than was possible at Florence. Their combined out-put summed up most of what was finest in Venetian painting from the middle of the 15th to the middle of the 16th century.

As to Titian himself, his personality is vivid from contemporary accounts and letters as well as from his pictures. He was earthy, extroverted, healthy, sensual, ambitious, with a peasant shrewdness and, at times, a peasant hardness, slightly unimaginative, immensely hard working, notoriously avaricious and splendidly talented. The portrait of a young man, now at Washington (plate 19) shows just such a one, and may well be the earliest surviving likeness of Titian. He came from Pieve di Cadore which lies a few miles down the valley from Cortina

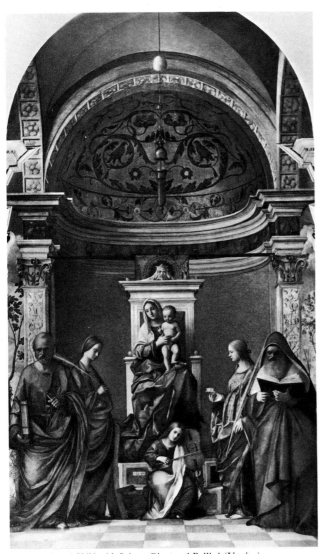

2 *Madonna and Child with Saints:* Giovanni Bellini (Venice)

d'Ampezzo in the Dolomites. Members of the painter's family had been lawyers and army officers, and would therefore have been of some standing in the community. Snow in winter, torrents in spring and precipitous mountains in all seasons would have been the background to his childhood.

The miracle of genius descending on a child born in so remote a community transferred him at a relatively early age to the nearest big city – Venice. By this move the boy from Cadore would have exchanged the pure air of the Alps for the relaxing climate of the lagoons, the mountainous scenery for the pervasive canals, and wooden huts and peasant clothes for palaces, gold mosaics, marbles, glass, velvets, damasks and the obtrusive evidence of oriental trade. Such a contrast would be almost overwhelming to anyone at any time. But we do not know precisely how or when it occurred in the present instance, though Titian is said to have been about nine or ten at the time. He is also said – on fairly good authority – to have been apprenticed in Venice to the mosaicists, the Zuccati, and then in succession to the brothers Gentile and Giovanni Bellini, who, whatever the precise years when this occurred, would certainly have been already elderly (Gentile died, probably in his upper seventies, in 1507; Giovanni may have been younger, but not much).

The example of the serene and lovely painting of Giovanni, at least, (figures 2-3) undoubtedly had a deep and lasting effect on the young Titian – particularly in the sphere of the altarpiece. But the old man was himself facing competition from a meteoric young star, who, at least for a time, affected Titian more violently. This was Giorgione. He was still young when he died of the plague in 1510, and that fact and his early fame have created such a legend that it has been almost impossible to separate fact from fiction, and thus to define his work. But the mere fact that so many of the pictures attributed to him have at other times been ascribed to Titian at least shows the degree of resemblance. And though in theory it could have happened that it was Titian who influenced Giorgione, the sum of the dreadfully scrappy evidence leaves little doubt that it was the other way round. The important contract to decorate the exterior of the German merchants' palace (the Fondaco dei Tedeschi) went in the first instance to Giorgione: Titian merely got a little of it as an afterthought.

We must therefore follow fact, as well as logic, in attributing the characteristics of what has long been called the Giorgion-

esque movement in painting to Giorgione himself, and see in it the most important influence on the young Titian. What are those characteristics? The Giorgionesque was essentially not monumental. It was intimate, informal, lyrical and poetic. Though it was sometimes compelled to concern itself with religious pictures and histories on a biggish scale it is at its most typical in smaller pictures intended for enjoyment in a private house. Above all, it focused great attention on landscape, and explored a new relationship between it and the figures in it. Previously, landscape had been merely an occasional background to figures. Now it becomes as important as they are. In the picture of a sunset, now attributed to Giorgione (figure 10), or in his famous *Tempest* the landscape almost overpowers the figures, but not quite. Giovanni Bellini, also a pioneer of landscape, had sometimes been working in this direction, but even in his most extreme examples in this vein – such as *The Agony in the Garden* (fig 3) – his figures are relatively more prominent than Giorgione's.

Titian's essays in the Giorgionesque – that is, pictures such as the *Three Ages of Man* (plate 3) which are certainly his work and not Giorgione's – are perhaps slightly less whimsical than Giorgione's *Tempest,* but in general accord closely with the dreamy and poetic mood of that painting. And throughout his life – up to works of his extreme old age, such as the Vienna *Nymph and Shepherd* (plate 47) – the idea of figures in a landscape, and of landscape as the best of all possible backgrounds to figures, remained among the most constant characteristics of Titian's art. His technique broadened and increased its range. More important, his eye for colour continued to explore the long transition from gorgeous local shades to a complicated balance of related tones. But his interest in landscape for its own sake remained unshaken.

Giorgione's early death undoubtedly helped Titian's career. And the fact that he is said, on early authority, to have completed certain works left unfinished by Giorgione suggests that, in the modern sense, he inherited Giorgione's practice. It may or may not be significant, for instance, that Titian's earliest surviving works outside Venice – the frescoes in the Scuola del Santo at Padua (plate 2) – date from immediately after Giorgione's death. There were painters at the time who were native of Padua, and the decision to employ a painter from Venice would have represented a step of some consequence.

Had the authorities originally intended asking Giorgione to do the job? We have no evidence, but from this time on Titian's fame outside Venice increased, and for the rest of his very long life he was more often working for outside patrons than for Venetians.

Giorgione's unexpected death was not the only stroke of luck which helped the career of the young Titian. In the next year – 1511 – the most talented of Titian's contemporaries – and his most likely rival – left Venice for Rome where he settled for good. This was Sebastiano del Piombo. And when, only five years later still, Giovanni Bellini died, Titian, still probably only in his thirties and with all three of his chief rivals removed, must have felt the world was at his feet.

In fact it was, but only because of a rare combination of circumstances not directly related to the degree of his artistic talent. Then in addition to the providential removal of his rivals, two factors in particular assisted Titian in his fabulous career. With the single exception of Michelangelo, those artists who enjoyed the most conspicuous worldly success in the Renaissance and Baroque periods, whatever else they might be, were always great portraitists. Though he rarely had time to take advantage of it Raphael was one of the greatest. So was Rubens, so was Van Dyck, so Velázquez, and, in sculpture, Bernini. Rembrandt's skill as a fashionable portraitist brought him a fortune early in life, and when his interest in this branch of art waned so did his earnings. The princes of the world might have appreciated religious pictures as an aid to their devotions, and the more lascivious among them, at least, have shown a marked partiality for nudes. But if an artist, no matter what his other talents or preferred type of subject might be, was able to paint a portrait of a notability which was both a recognisable likeness and showed him as slightly more handsome than he normally appeared, and if, above all, he could suggest in his portrait that his sitter was of great importance in the world, then he was a made man. He had immortalised the prince, ensured his fame and earned his gratitude. Such, in brief, was Titian's contribution to the art of portraiture. The field was enlarged from head-and-shoulders to half- and full-length, and accessories added to illustrate the sitter's interest and importance. If, in addition, such an artist – and Titian was pre-eminently such – could command the services of a publicity agent of genius the formula is complete. It was here that Titian scored over all

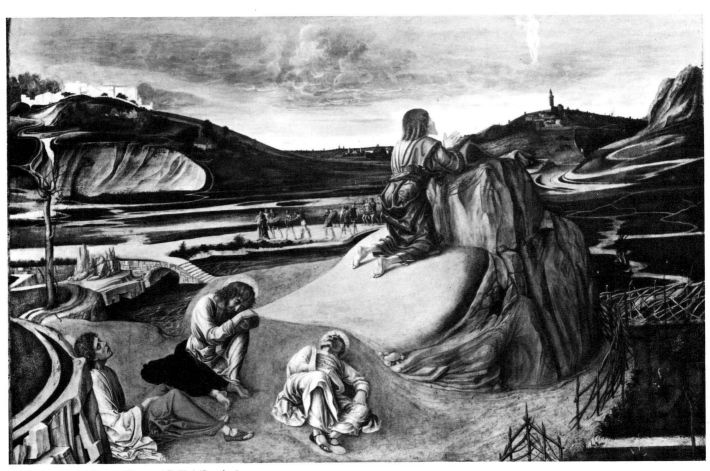

3 *The Agony in the Garden:* Giovanni Bellini (London)

others. By an unprecedented mixture of flattery, effrontery and blackmail his friend the writer and political pamphleteer, Pietro Aretino, had put himself on correspondence terms with almost every prince in Europe. His motive, in the first place, was a selfish one; he extorted money from notabilities who were afraid of his satires if they refused. But he was quite willing to put the service at Titian's disposal.

Not all of Titian's introductions to the great came about in this fashion. The earliest of them, for example – Alfonso d'Este, Duke of Ferrara – may not have been connected with portraiture and certainly occurred before Titian knew Aretino. But his contacts with the Gonzaga at Mantua, with the Emperor Charles V, with Pope Paul III and with Philip II of Spain all started in the same way. With or without Aretino's introductions Titian began by painting a stunning portrait of the prince. That was enough to reverse the roles of patron and painter. Henceforth it was the prince, and not the artist, who was the suppliant. And the prize need no longer be restricted to portraiture, since Titian was equally pre-eminent in all other genres as well, whether mythological, religious or imaginary portraits of long-dead heroes. This last, which reflected a curious taste, we may think, was much to the liking of the man of the Renaissance. Titian's 'portraits' of the Caesars – who had lived and died more than a thousand years before he was born – were among his greatest triumphs.

With many of the rulers of Italy, and some of those outside it, competing for his services with the churches of Venice and the Venetian state itself, it is hardly surprising that during much of his career Titian walked a tight rope, deciding how long it was safe to keep which noble client waiting, the variables being his importance, his impatience, the magnitude of the undertaking and the amount of time he had already waited. Oddly enough, though the first of Titian's major opportunities outside Venice came to him through a portrait, he declined the offer. The famous scholar, Pietro Bembo, had been painted by him. When, in 1513, he became secretary to the new Pope, Leo X, he tried to persuade Titian to come to Rome. But Titian preferred to apply for work from the Venetian government, even though it had not been offered him. He volunteered to contribute to the unfinished decoration of the great room in the Doge's Palace, an undertaking which in the event dragged on for many years and then perished in the fire of 1577. One of Titian's contributions –

The Battle of Cadore (see Biographical Outline) – is known from engravings and seems to presuppose some knowledge of Leonardo's battle cartoon, which had been executed at Florence in the early years of the century. Though Titian did not get to Rome or Florence until many years later, he seems to have had remarkably keen antennae and to have formed some idea – derived presumably from eye-witness sketches and an occasional engraving – of antique sculptures and the works of Raphael and Michelangelo in Rome and Florence, long before he saw the originals for himself.

Titian's connection with Alfonso d'Este at Ferrara, which produced, in the bacchanals series (plates 15-16) one of the greatest decorative schemes of the Renaissance, as well as some of the supreme illustrations of antiquity, starts mysteriously. Giovanni Bellini seems to have begun a picture (fig. 6, the so-called *Feast of the Gods*) for Alfonso's sister, Isabella d'Este, several years previously – around 1505. For some reason it was never delivered. Instead it was taken over by Alfonso from Giovanni Bellini, who signed it and dated it 1514, but probably received some help – being now very old – from Titian. Even before Bellini died, two years later, Titian was being employed on his own account by Alfonso, though there is no knowing if the connection started through Bellini's picture. Soon afterwards fortune favoured Titian again by the removal of two more rivals. Both Fra Bartolommeo and Raphael had been engaged – at a distance – to contribute to the decoration of Alfonso's Studiolo in the Castello of Ferrara. Both died before doing so (in 1517 and 1520 respectively) and in both cases the jobs seem to have gone to Titian instead. In the case of the first he even seems to have drawn on Fra Bartolommeo's design. This was for *The Worship of Venus* – an astonishing subject for an artist who was a Dominican friar. A drawing by him survives which was evidently the basis of the first of the bacchanals which Titian painted for Ferrara. The development of the series was unusual in that Bellini's picture became the model for the rest, but would originally have been painted to the specification of someone else, namely Isabella, and for another purpose. Soon after it was delivered Alfonso seems to have hit on an idea for unifying the whole series. This was that it should be a reconstruction of certain paintings described by antique writers. Titian's three contributions – *The Worship of Venus* (Prado), *Bacchus and Ariadne* (London, National Gallery) and

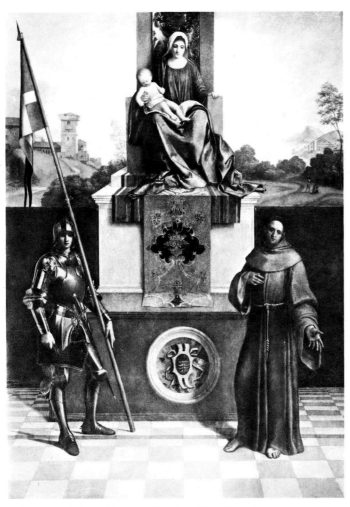

4 *Madonna and Child with Saints:* Giorgione (Castelfranco)

Bacchanal of the Andrians (Prado) – are based on descriptions of imaginary works of art in Philostratus, Catullus and Ovid, and we know that Alfonso d'Este himself devised the programmes and gave them to the painter. We also know a good deal about Titian's methods of painting them. As always, he was slow. His innate tendency was to take his time, to put a picture aside soon after starting it, to think about it, to take it up again and then shelve it once more. In this way he might have on his hands several dozen pictures at a given moment, intended for different patrons, and the studio procedure and organisation was further complicated by his habit of sometimes touching up his students' copies of his pictures and selling them as his own.

In the case of the Ferrara bacchanals Titian was sent stretched canvases by Alfonso – to ensure that the size and shape of the new picture accorded with that of those already there. He then started work at his leisure, turning a deaf ear to Alfonso's repeated reminders to hurry up until such time as he realised that the Duke's patience was at an end. Thereupon he had the canvas sent by water to Ferrara and then went there himself to finish it on the spot.

It is likely that Titian's work for two other local courts – those of Mantua and Urbino – came to him because the princes in question were related to Alfonso d'Este and had seen his work for him. His first portrait for Federico Gonzaga (Alfonso's nephew) at Mantua can no longer be identified. But the marvellous *Entombment*, which is now in the Louvre (plate 17) (like other Gonzaga pictures it was first sold, in 1628, to Charles I, and then passed after his execution to Cardinal Mazarin), is perhaps the finest and must have come early in the series. The Gonzaga duke had inherited magnificent pictures by Mantegna, and he had at his disposal the services of Raphael's pupil, Giulio Romano, as resident architect, painter and director of arts. The series, already mentioned, of portraits of the Caesars which Titian painted for him in the later 1530s may have been intended in some fashion as counterparts of Mantegna's series of *The Triumph of Caesar* (now at Hampton Court).

In the case of Urbino, the duchess was Alfonso's niece, being Federico Gonzaga's sister. The duke, Francesco Maria della Rovere, first ordered a 'portrait' of Hannibal from Titian, specifying that it had to be as good a likeness as possible. Later he and his duchess were both portrayed by Titian and over a long period he and his successor received many other

pictures, including both the famous *Venus* (plate 18) and the penitent *Magdalen* (Pitti).

In the meantime Titian had also done important work for his home city. Owing to the protracted delays in finishing the work for the Doge's Palace, something else was needed to demonstrate in Venice itself his superiority over all other painters. This opportunity came with the commission for the Frari. It was for the high altar of the largest church in Venice. No one could wish for a finer chance to stun the world . . . or make a fool of himself. A gigantic marble frame, over twenty feet high, had been set up at the Prior's expense in 1516. Now it was a question of filling it. The result – *The Assumption of the Virgin,* (plate 11) which is still in position – was, for Venice, somewhat what Michelangelo's Sistine ceiling was for Rome. A bombshell. We know from Lodovico Dolce's book, *L'Aretino,* which was published within Titian's lifetime, that the great picture shocked conservative taste in Venice. It was too violent, too animated and too novel to be immediately acceptable in the context of the placid art of the Bellini and their followers. Only one other picture seems ever to have created such a *succès de scandale* in Venice. That occurred thirty years later, in 1547-8, in connection with Tintoretto's *Miracle of St Mark,* which again seemed disquietingly revolutionary at first.

How far, if at all, Titian himself may actually have been influenced in the *Assumption* by what he knew of the Sistine ceiling cannot be decided, as we do not know how far his knowledge of it went. But the violence and drama which he evokes in the saints at the base does remind us far more of scenes such as Michelangelo's *Creation of the Sun and Moon* than of anything in earlier Venetian painting. And like these scenes in the Sistine ceiling it now seems to look forward to the Baroque, rather than to the more placid aspect of High Renaissance art. A second great altarpiece in the same church shows a similar tendency in another form. The *Madonna of the Pesaro Family* (plate 13) was commissioned by the bishop of Paphos who, some twenty years before, had commissioned one of Titian's earliest works (plate 1). Like the *Assumption,* it is unusual in Titian's work in showing no landscape background, though only the most distinguished landscape painter could have achieved the exquisite and brilliant lighting of the clouds. In its day it would have been almost as revolutionary as the *Assumption,* in the system whereby the spectator's eye is led into the picture by means of St Francis'

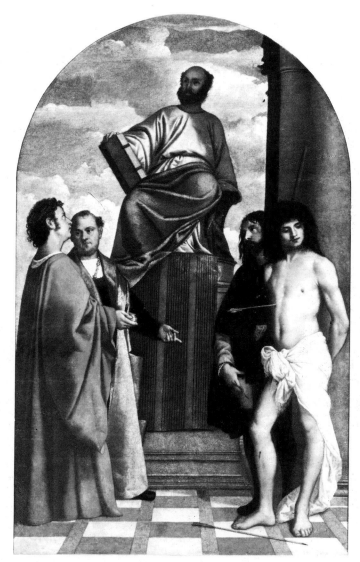

5 *St Mark and other Saints* (Venice)

outstretched left arm (on the right of the picture) and in the asymmetry of the placing of the Madonna and Child. This type of design became, like much of Titian's work, immensely influential. One of Veronese's greatest altarpieces (*The Marriage of St Catherine*, now in the Accademia at Venice) and a number of 17th-century altarpieces are evidently based on it, and their relationship to it illustrates a recurring phenomenon in the history of art – namely, that something which is originally caused by functional considerations is often perpetuated merely for decorative ones. So it was, for instance, with the *guttae* on the entablature of Greek temples. In the days when the building was of wood these little objects would have been simply the projecting ends of the nails or pegs which held the beams. Later they were retained – translated into marble – as decoration.

So it was with the Pesaro *Madonna*. It was painted for an altar on the left hand side of the church as one faces the high altar (it is still there), and there seems no doubt that this asymmetry which became so influential in this type of picture originated merely for this reason. In the past, no matter in what out-of-the-way corner of a church a given altarpiece happened to be located, it was assumed that the spectator did not look at it until he was standing immediately in front of it. The perspective, and indeed the whole picture, was calculated from this angle. But in the Pesaro *Madonna* Titian evidently had the idea – and simple as it now seems, it would have required a degree of perception amounting to genius to hit on it in the first place – that the spectator's eye might stray diagonally to the left hand wall – or might be persuaded to do so if the picture were sufficiently striking – while still walking east up the central aisle. Therefore he calculated it from that angle, placing the Virgin and Child well to the right of centre and working out the perspective accordingly. But in Veronese's picture the conditioning factor no longer existed. It was not for a side altar but for the high altar (of St Catherine's church in Venice) in the very middle of the centre axis. The asymmetry in this case has therefore no functional justification: it is merely an artistic device (fig. 7).

The Pesaro altar was unveiled in 1526, and soon afterwards Titian embarked on a third altarpiece which was universally considered his masterpiece. This was *The Death of St Peter Martyr*, painted in 1528-30 for the Venetian church of St Zanipolo (SS Giovanni & Paolo) where it was destroyed by fire in 1867. From the numerous surviving copies, and from Rota's engraving (fig. 8) we can derive some idea of it, and we may wonder if we should still rate it as high as our predecessors did. At least it is not difficult to see where its appeal lay, and how it related to the earlier altarpieces. It is as dramatic as the *Assumption* though containing fewer figures (only three, in fact), and as asymmetrical as the Pesaro *Madonna*. Unlike them it incorporates one of Titian's greatest strengths – landscape – which would not only have been superbly painted in itself, but superbly adapted to heightening the drama. The trunk of the huge tree in the centre bends towards the left in conformity with the main rhythm of the picture, and its branches and leaves – and, no doubt, the lighting and colours whose effect we can hardly guess – heighten, and almost comment on, the tremendous agitation of the scene.

As in the *Assumption*, parts of the *Peter Martyr* – particularly the stupendous figure on the left – remind us of the Sistine ceiling, and in this case there is a tantalising possibility of a connection, since Michelangelo actually happened to be in Venice during some of the time that Titian was painting the picture. But this was not till the autumn of 1529, and as the great picture was delivered in the spring of the following year, and had probably been finished earlier, it is hard to believe that any substantial modification can have been made at so late a stage.

In the event the *Peter Martyr* proved to be the climax of what may be called the proto-Baroque phase of Titian, though some later echo of it may be found in the San Spirito ceiling paintings dating from 1543, and now in Santa Maria della Salute. By comparison, the work of the 1530s suggests a period almost of marking time and has certainly less easily definable characteristics. The next surviving large-scale work – *The Presentation of the Virgin* (plate 25) seems tame in comparison with the *Peter Martyr* or the *Assumption,* and in the event represented a kind of swan song of the earlier Titian. If the output of his hugely long career is roughly split into categories of 'early' and 'late' the break would come around the year 1540. A comparison of *The Presentation of the Virgin* (which was finished in 1538) with the Vienna *Ecce Homo* (1543, plate 33) shows the change very clearly. The serenity both of design and also of conception and handling of the earlier work gives way to agitation – of an inherent kind, quite different from the impetuous drama of the *Assumption* or the *Peter Martyr* – and the technique becomes correspondingly less finished, more 'Impressionist' and more

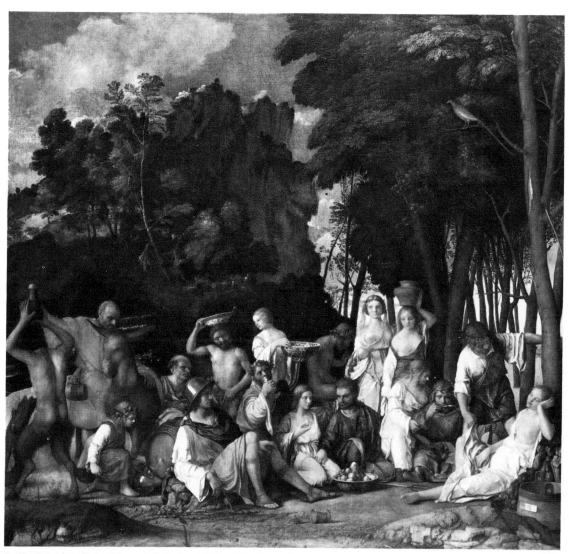

6 *The Feast of the Gods:* Giovanni Bellini and Titian (Washington)

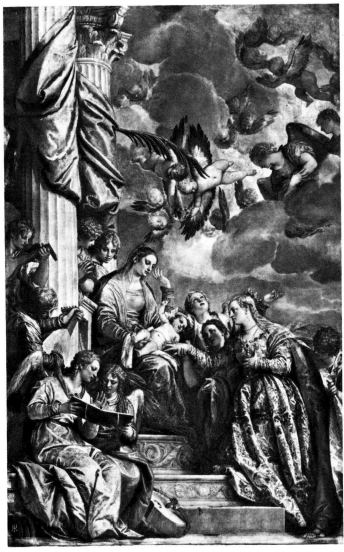

7 *The Marriage of St Catherine:* Veronese (Venice)

forceful. These tendencies continue and increase in the later Titian.

This – the 40s and 50s of the 16th century – was the period of Titian's greatest, and almost unimaginable glory in the worldly sense, when he was working for the greatest sovereigns on earth – the Emperor Charles V, Pope Paul III and King Philip II of Spain. It was also the period of vast political and spiritual upheavals. Venice, having lost nearly all her possessions outside the city itself, was now weaker than for several centuries, and the rising tide of the Counter-Reformation and the increasing vigilance and intolerance of the Roman Catholic church affected the lives of everyone. Titian first met Charles V in 1530 – according to Vasari, who adds that the introduction came about through Pietro Aretino – when the Emperor and the Pope (Clement VII) were reconciled at Bologna (three years previously the Imperial army, under-paid, and full of rabidly anti-Catholic Lutherans, had got out of control and had sacked Rome with almost unprecedented horrors). Titian and Charles met again at fairly frequent intervals, and there is little doubt that the Emperor's interest was stimulated in the usual way: he had seen a portrait by Titian (of Federico Gonzaga) and wanted one of himself. But there is some uncertainty concerning which pictures were ordered when and some mystery too. One of the surviving Titian portraits of the Emperor, for instance – the one now in the Prado showing him at full length with a large dog – was apparently not done from the life, being a copy of a portrait by the Austrian painter, Jakob Seisenegger. Another, of Charles in armour, is known from descriptions and prints, but the original was burnt. Titian's most important work for the Emperor was done later in his career. But in the meantime we know a good deal of Charles's attitude to him, and this is of the greatest interest. In a citation given at Barcelona in 1533, creating Titian Count Palatine – an extraordinary distinction in itself – the Emperor compared himself with Alexander and Titian with Apelles. When his action was questioned Charles replied that he could create many counts but not one Titian, and when the painter dropped his brush the Emperor picked it up for him.

Titian's relations with the Farnese Pope, Paul III (who succeeded Clement VII in 1534) also arose through a portrait, and led to his only visit to Rome. As early as 1539 Aretino had done his best, apparently without success, to gain him commissions

for portraits from the Farnese and also from the Medici. But when the Pope's young grandson, Ranuccio Farnese, who lived in Venice, was painted by the master the result led to a commission, in 1543, to paint His Holiness, then on a visit to Ferrara and Bologna. The stupendous result (plate 27) led in its turn to the inevitable sequel. Pressed to go to Rome Titian at first resisted – he was certainly over fifty at the time – and then, with the bait of an ecclesiastical benefice for his good-for-nothing son, Pomponio, gave in. He travelled like a prince via Ferrara and Pesaro, and arrived on October 15th, 1545.

Titian's eight-months' stay in Rome witnessed much sight-seeing and a good deal of work. The extraordinary portrait group of the ancient pontiff and his sanctimonious grandsons (Plate 28) is the most remarkable surviving document of it. But perhaps we may linger more attentively on another incident. Vasari tells us that on this occasion he himself accompanied Michelangelo on a visit to Titian. What would we not give to have witnessed this encounter! It is so tantalising as almost to induce nausea. Yet we must keep a sense of proportion. For no one, in the flesh, could remotely live up to the god-like reputation which both Michelangelo and Titian have earned in subsequent centuries. No matter how they may in fact have appeared or behaved we should, with our fore-knowledge, be disappointed to meet either; and therefore also to witness the encounter. And in fact we can gain a fair idea of it, reading between the lines of Vasari's account. Michelangelo censured Titian's draughtsmanship . . . though not until he had left the studio (had the remark been made to his face Titian could have turned the tables, as the picture of his in question – Naples *Danäe* – seems to derive from Michelangelo). A fly on the wall would therefore, in all probability, have witnessed a slightly stiff encounter between two vigorous and elderly men (Michelangelo speaking his beautiful Tuscan, Titian with his Alpine gutturals merging in the equally strange dialect of the Venetian lagoons), both somewhat on their guard but both also on their best behaviour. It must have been not unlike two celebrated tennis players exchanging civilities before and after a final at Wimbledon.

For his return to Venice Titian chose another route – to include Florence, also for the first time. Here he seems to have been less successful, and we may well imagine that a court which relished the extreme sophistication and artificiality of

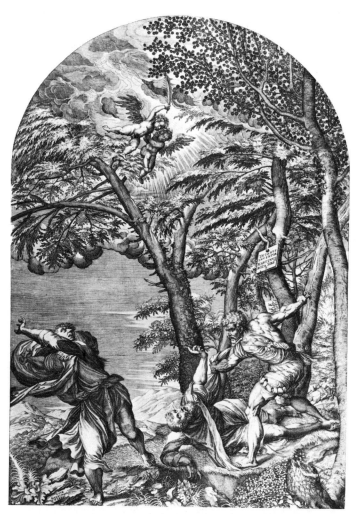

8 *The Death of St Peter Martyr:* Rota after Titian (London)

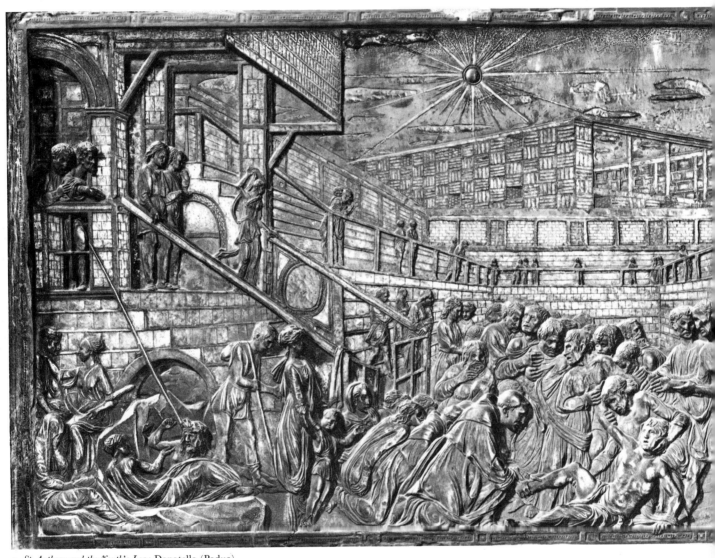

9 *St Anthony and the Youth's Leg:* Donatello (Padua)

Bronzino's painting might consider Titian's grandeur to be lacking in refinement. The ostensible reason for his journey to Rome – the obtaining of a benefice for his son – was not achieved at the time, but the negotiations entered into then bore fruit soon afterwards.

Titian had only been back in Venice some eighteen months when he was summoned (January, 1548) to join the Emperor at Augsburg. Charles had won a spectacular victory at the battle of Mühlberg and wanted Titian to commemorate it. Important as was the celebrated equestrian portrait (fig. 11) which resulted from this visit – the first occasion, so far as we know, on which the painter had penetrated to the other side of his native Alps – it was followed by something more significant still on the long view, namely a patronage which became the most important in the whole of Titian's life. The new patron was not the Emperor, though he continued to employ Titian, but his son, Philip.

The story of Titian's relations with the King of Spain, Philip II, is more or less the same as the story of the last twenty-five to thirty years of the painter's astonishing career. Titian first met Philip in 1548 when the prince was only twenty-one and the painter at least sixty. They met again two years later for the second and last time. Thereafter – for twenty-five years – Titian continued to send pictures from Venice to his unseen patron wherever he might be at the moment – in England, as the conscientious husband of Mary Tudor, at Brussels or at home in Valladolid or Madrid or the Escorial. During this time Titian executed several portraits in Venice and a few local commissions – altarpieces for San Salvadore, Venice or for Ancona, or ceilings for Brescia town hall. But throughout this quarter of a century, when his art was at its maturest, he seems to have reckoned that Philip was entitled to the first call on his services.

Some programme, as we shall see, had evidently been agreed on in advance. But some license in interpreting it seems to have been assumed, and throughout the time when he was working it off Titian was in the habit of sending the king small extra pictures which he had not ordered, partly, no doubt, to keep him quiet until the larger ones which he had commissioned were ready. When, after about a dozen years, the programme was completed Titian extended this principle. Once or twice thereafter the King asked for pictures of specific subjects. But more often Titian seems to have used His Catholic Majesty as a

kind of waste-paper basket or Aunt Sally. He painted what he liked and then sent it off to the king, accompanying each dispatch of paintings with more and more insistent demands for money and less and less truthful accounts of his grievances.

When we try to trace this singular relationship from the beginning we must admit that the initial spark must have come from Philip. Granted, Titian could take his choice of customers from among the crowned heads of Europe. But even he could not force them to employ him, and the spectacle of a young man of twenty-one asking for pictures of this kind is in itself a phenomenon interesting enough to be investigated. For before he had ever seen Titian, indeed, as soon as he arrived in Italy, the young prince summoned the old painter to his presence. Writing to Bishop Granvella on December 17th, 1548, Titian, who had himself only recently returned to Venice after eight months' work for Charles V at Augsberg, said that he had been called with great urgency to meet the prince at Milan. Philip had only reached Genoa on November 25th. On December 20th he entered Milan where, presumably, Titian arrived soon afterwards. Philip stayed less than three weeks at Milan, since he had been summoned to rejoin his father and to visit the Netherlands over which he was to rule.

As usual, the appetite of the new princely client had probably been whetted by seeing Titian's portraits (in Philip's case, probably those of his father, the Emperor). The first aim of the encounter would therefore have been to have his own taken, and we know that this was done. Titian made sketches of the prince at Milan and then worked them up into a portrait which he sent from Venice. Perhaps in Italy, and certainly when he reached the Netherlands, Philip would have seen examples of Titian's skill in other fields. His aunt, Mary of Hungary, had a set of mythologies – the so-called *Furias* (heroic punishments of legendary figures) – at her château at Binche. When he went on to Augsburg Philip would also have seen the *Venus* which Titian had brought there in 1548.

It is usually stated that it was the Emperor who sent for Titian to come to Augsburg for the second time, in 1550, as he had undoubtedly done two years previously. It is indeed possible that he may have sent some such message. But it is certain that Philip did so. In a letter of September 12th, 1550, the prince writes from Augsburg to the Spanish ambassador in Venice: 'You replied to a letter of mine concerning Titian's

coming, that he would leave as soon as the dog days were over and the rains had fallen. I have been expecting to hear from you that he had left, but as you have written nothing about it I am afraid there may be some further delays. I should be very glad if he came as soon as possible.'

It was during this stay that Titian and Philip must have agreed on the programme of pictures which Titian was to send from Venice over the succeeding years. The opportunity was also taken to paint further portraits of the prince, and a letter of Philip's written in this connection demonstrates that despite his good taste, which was surely remarkable in one so young, he had not yet fully grasped the point of Titian's current style. 'With this' he writes, in a letter of May 16th, 1551, (meaning by the hand of the Duke of Alba, as he did not trust the ordinary courier) 'go the portraits by Titian which your Highness [his aunt, Mary of Hungary] ordered me to send you, and two others which he gave me for your Highness. In the one of me in armour there well appears the haste with which he has done it, and if there had been more time I should have made him do it again. The varnish has spoilt the other a little, although not in the action and that could be put right there. The blame is not mine but Titian's'. Later on, Mary of Hungary, wiser than her nephew, pointed out in a letter to Mary Tudor that the Titian portrait which she was sending must be looked at from a distance, 'like all Titian's paintings'. From Philip's letter we can assume that the portrait he speaks of is the one now in the Prado (plate 29), among the most splendid of his full-length ones.

The spring of 1551 was the parting of the ways as regards direct contact between Titian and Philip. The Indian summer of the ageing painter's travelling was now over. He returned to Venice and never again left Italy. Philip went back to Spain, and from there to England when he married Mary Tudor in 1553. From 1554 to 1559 he was mainly in Flanders. Thereafter he returned to Spain for good. The stage was now set for the pattern of the last fifteen years of Titian's life – the dispatch of pictures to Philip, wherever he might happen to be.

This traffic was slow to begin. Though Titian would have been back in Venice by the middle of 1551 it was several years before Philip received pictures which had been painted specially for him. In a letter of September 10th, 1554, Titian explains the reason for this: the pictures for Philip would have been finished long before had it not been for the work he had

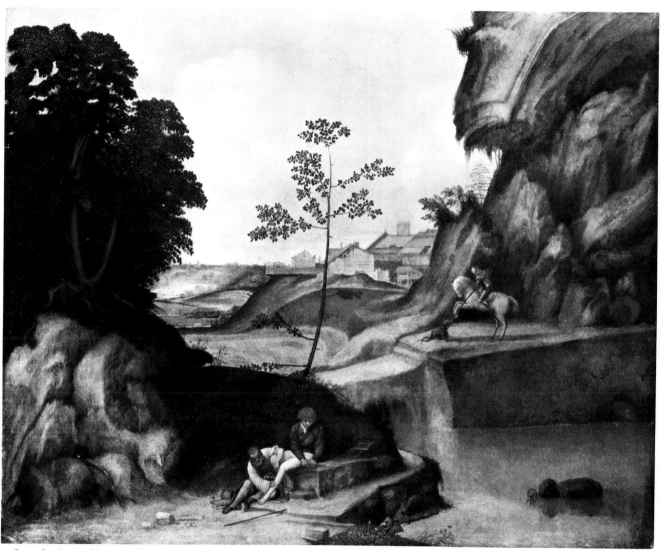

10 *Sunset Landscape:* Giorgione (London)

been putting in on the *Gloria* (plate 30) for the Emperor – a huge altarpiece, clearly involving several years' work, which Charles finally took with him to the monastery in Spain when he abdicated.

The pictures which Philip was most anxious to get were almost certainly the mythologies – Titian himself called them *poesie* – which did not in fact start to reach him until 1554. It is likely that he had given careful verbal instructions concerning them when he last saw Titian, and likely too that it is to them that he refers in a cryptic passage in a letter to Titian of December 12th, 1552: 'Don Juan de Benavides will say to you what I shall refrain from setting down here'. What did he mean by this? Clearly, nothing to do with money, as neither party ever scrupled to mention it, Titian, indeed, doing so *ad nauseam*. Perhaps we may find a clue in a letter from Titian of two years later in which he contrasts the *Danäe* (plate 38) which he has sent to Philip with the *Venus and Adonis* (plate 39). He points out that the attitudes of the nudes are complementary, one seen from the front, the other from the back. He adds that in the *Perseus and Andromeda* yet another aspect will be shown. It therefore seems likely that the message which Philip had been reluctant to commit to paper related to an erotic element desired by him in the nudes. As he was still under thirty at the time this is perhaps understandable.

Though certain of the religious pictures sent by Titian to Philip – the *Entombment* (plate 48) or the great *St. Lawrence* – are of the first quality, it is these *poesie* which, on the whole, are still of the greatest interest to us. Strangely enough, the two which were sent first – the superb *Danäe* (plate 38) and the slightly disappointing *Venus and Adonis* (plate 39) – are the only ones of this particular series which are still in Spain. The others left the Spanish royal collection in the 17th and 18th centuries, and these include the two *Dianas* from Bridgewater House (plates 40-43) and the Boston *Europa* (plate 44) which are the finest of the series and the great secular masterpieces of the second half of Titian's life.

Inevitably we compare them with those painted thirty or forty years earlier for Alfonso of Ferrara. Probably Titian, too, was casting his mind back to them, since the size and shape of most of them – dictated originally, it will be remembered, not by himself or Alfonso but by Isabella d'Este to Giovanni Bellini – is more or less the same. This time, understandably, the series took even longer to reach Philip than the bacchanals had done to get to Alfonso. The first, the *Danäe* (plate 38), was sent off in 1554. The last, as far as we know – the *Europa* (plate 44), in 1562. The *Danäe*, which is of more oblong format than the others, was merely another version of a composition, now at Naples, which had been painted earlier for Alessandro Farnese. It would be interesting to know whether Philip had seen and admired the first version, or whether he was in ignorance of its existence. Like the *Venus and Adonis* (and also the *Perseus and Andromeda* in London) it shows some influence of Mannerism which would have come to Titian during his visits to Rome and Florence. The varnish of the *Venus and Adonis* is now very yellow, and the *Perseus and Andromeda* is both dirty and half ruined. But by good fortune the remaining three, the *Dianas* and the *Europa*, are much less damaged and all three have been cleaned during the present century. It is therefore not unfair to compare them with the bacchanals.

Naturally this must be in the mind's eye, and with the aid of photographs. If the two bacchanals (Prado) and the *Bacchus and Ariadne* (London) could be physically juxtaposed with the *Dianas* (Edinburgh) and the *Europe* (Boston) what an exhibition it would be! But since each of them would be worth well over a million pounds we must dismiss this idea and revert to our memories and slides. How does the old Titian's return to the themes of his youth compare with what he did then? Certainly there has been no falling-off of quality. Rather, the differences are what we should expect. What was spring-like is now autumnal, what was smooth is now rough, and what was calm is now agitated. This difference in mood is particularly clear if we compare the *Bacchus and Ariadne* with the *Diana and Actaeon*, since the subjects and their arrangement have much in common.

Both pictures depict an unexpected encounter of a man and a woman, and the surprise of each at seeing the other. Pictorially, the roles are reversed in the two pictures. In the earlier one it is the female, Ariadne, who is on the left and who raises her right hand in surprise and alarm. In the later one it is the man (Actaeon), and he raises both of his. In the *Bacchus and Ariadne* the two main figures are not separated by any others, and so all the figures in Bacchus's train on the right hand half of the picture may be considered non-essential to the main action. In the *Actaeon* the drama is intensified by separating the two principals by the full width of the canvas. The eye is first caught

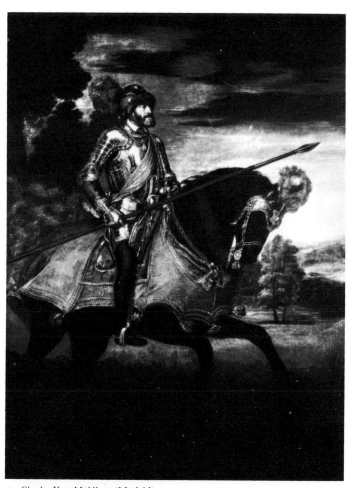

11 *Charles V at Mühlberg* (Madrid)

by the glorious red curtain outlined against the blue sky in the archway, then it alights on Actaeon's frozen astonishment, and finally is led across the forms of the horrified nymphs to the object of his gaze, Diana herself. And here is the biggest and most significant difference in mood between the two pictures. There is an air of dreamy unreality about the *Bacchus and Ariadne*: both the principals show expressions of wide-eyed astonishment which is innocent in nature and devoid of disquieting implications. But now look at Diana. Could anything be more sinister than her expression as she balefully looks sideways exactly as Ovid describes her in the *Metamorphoses* (he writes of her 'turning aside a little, and casting back her gaze')? Her malice and resentment are terrifyingly apparent, and the mood is echoed by the wild cry of the reclining nymph who lifts the curtain. We can believe without any difficulty at all that Diana is just about to inflict a savage death on a perfectly innocent man. And it is this mood of heightened drama and urgency that is altogether typical of the later Titian.

The nature of Titian's work for Philip II brought with it the disadvantage that he was unable to receive his patron's praise in person – something which was as necessary to him as to other creative artists. The occasional expressions of royal approval which reached him by letter must have been a poor second best. But in other ways the freedom involved to work in his own time and, more or less, at whatever he liked, would have been inestimably soothing as an occupation for his old age. And of course there were the occasional undertakings nearer home where he could establish personal contact with his clients – the magnificent night-piece (not shown) for the Crociferi of Venice, representing the Martyrdom of St. Lawrence (of which he later did a variant for the Escorial), or the splendid *Annunciation* (plate 49) for the church of San Salvatore which the painter defiantly signed 'Titianus fecit fecit' as though to refute allegations that he was past his best. As late as 1564 he was able and willing to travel as far as Brescia to supervise a commission for pictures for the town hall (which perished by fire soon after they were delivered) and at all times he would have been treated as a great celebrity by everyone in Venice. His avarice had long ago reaped its reward. He was rich, and he enjoyed it. The chance survival of a letter by the Latin scholar Priscianese gives a first-hand account of Titian's hospitality in 1540:-

I was invited on the day of the calends of August to celebrate that sort

of bacchanalian feast which, I know not why, is called *ferrare Agosto* – though there was much dispute about this during the evening – in a pleasant garden belonging to Messer Tiziano Vecellio, an excellent painter, as everyone knows, and a person really fitted to season by his courtesies any distinguished entertainment. There were assembled with the said M. Tiziano, as like desires like, some of the most celebrated characters who are now in this city, and of ours notably M. Pietro Aretino, a new miracle of nature, and, next him, as great an imitator of nature with the chisel as the master of the feast with his pencil – Messer Jacopo Tatti called Sansovino – also M. Jacopo Nardi and finally myself. I therefore made the fourth amid so much wisdom. Here, before the tables were set out, because the sun, despite the shade, still made his heat much felt, we spent the time in looking at the lively figures in the excellent pictures, of which the house was full, and in discussing the real beauty and charm of the garden with singular pleasure and expression of admiration from all. It is situated at the extreme limit of Venice, adjoining the sea, and from it one sees the agreeable little island of Murano, and other beautiful places. This part of the sea, as soon as the sun went down, swarmed with gondolas, adorned with beautiful women, and resounded with the varied harmony and music of voices and instruments, which, till midnight, accompanied our delightful supper.

But to return to the garden. It was so well laid out, and so beautiful, and in consequence so much praised, that the resemblance which it offered to the delicious retreat of St. Agatha refreshed my memory and my wish to see you. And it was hard for me, dearest friends, during the greater part of the evening, to know whether I was in Rome or Venice. In the meantime came the hour for supper, which was no less beautiful and well arranged than it was copious and well provided. Besides the most delicious viands and rare wines, there were all those pleasures and amusements that are suited to the season, the guests and the feasts. Having just arrived at the fruit, your letters came, and because, in praising the Latin language the Tuscan was reproved, Aretino became exceedingly angry, and, if he had not been prevented, he would have indicated one of the most cruel invectives in the world, calling out furiously for paper and ink, though he did not fail to do a good deal in words. Finally the supper ended most gaily.

We may wonder whether all the entertainment on that particular evening was as decorous, and as innocent, as the writer seems to imply. For it was not always. In one of his letters Pietro Aretino refers to Titian's appreciation of the ladies who were provided with the feast. 'He kissed them and played all sorts of foolish pranks with them, but goes no farther'. 'We might really follow his example', the old hypocrite adds.

Titian seems to have continued painting up to the end of his life – even then it was the plague, rather than the ailments of old age which claimed him – and Vasari, who came upon him doing so, said it might have been better had he given it up. It cannot be denied that some of the roughness in the pictures of Titian's extreme old age would have been caused by some degree of physical infirmity. On the other hand, it is these works which are perhaps the most moving of all to the 20th century. When we realise that the greatest painter is himself fallible, a bond is established more easily than with the unapproachable masterpieces of his prime.

Vasari's disapproval in this case merely showed that Titian's last manner was beyond him. And in other ways, too, Vasari's censure may be turned to Titian's advantage. For, like Michelangelo, Vasari deplored the fact that Titian, by his standards, could not draw. But for us, and for his more immediate posterity, this remark gives the key to what is perhaps the greatest of Titian's achievements. There had, indeed, been so many of them, and so remarkable, that to grade them is not easy. Starting by rivalling Giorgione on his own ground, the *Assumption* and *Peter Martyr* of Titian's next phase seem almost like Baroque works a century ahead of their time, while his full-length portraits established the aristocratic genre without which we cannot imagine Rubens, or Van Dyck, or Velàzquez, or Reynolds or Gainsborough. His work in landscape was equally momentous and far-reaching. But it was his innovations in the method of painting which were of the most vital importance, revolutionising, as they did, both the technique and the attitude of painters to painting for centuries to come. It was not, as Vasari claimed, that Titian *couldn't* draw. He could do so with considerable virtuosity when he wished, as we can see from the Brescia *St. Sebastian* (plate 14). It was, more simply, that Titian *liberated* painting from drawing. Before his time any picture could, with little effort of the imagination, be visualised as translated into sculpture. The folds in Bellini's draperies, even the strands of his figures' hair, are completely precise, because the paint is, physically, laid on an undercoat on which the lines are drawn. But throughout much of the surface of his pictures Titian seems to have painted directly on to the canvas, and thought primarily in terms of paint. The resulting forms could not be translated into another medium. It is paint for paint's sake. His brush at times visibly wriggled in it, and we know that at the end he applied much of it with his fingers. He was therefore the great forerunner of most of the true painters who followed him in time – Tintoretto, Veronese, El Greco, Velàzquez, Rubens, Van Dyck, Delacroix and Renoir. It is probable that no other painter has ever exercised so much influence for so long over so many great artists. Titian was the indispensible founder of what, until Cubism, was called 'modern painting'.

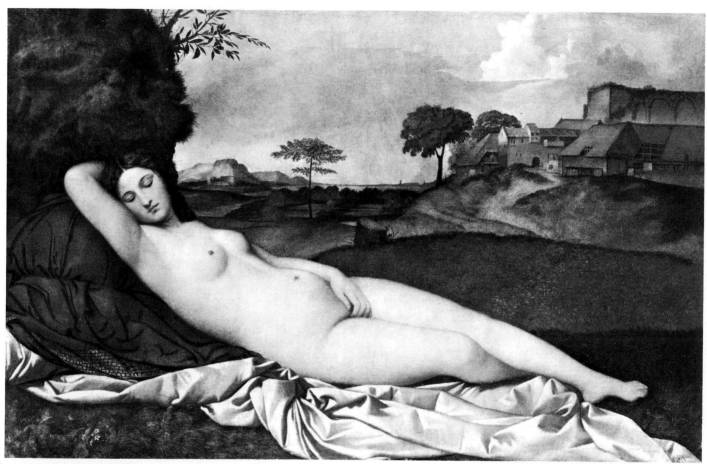

12 *Venus:* Giorgione (Dresden)

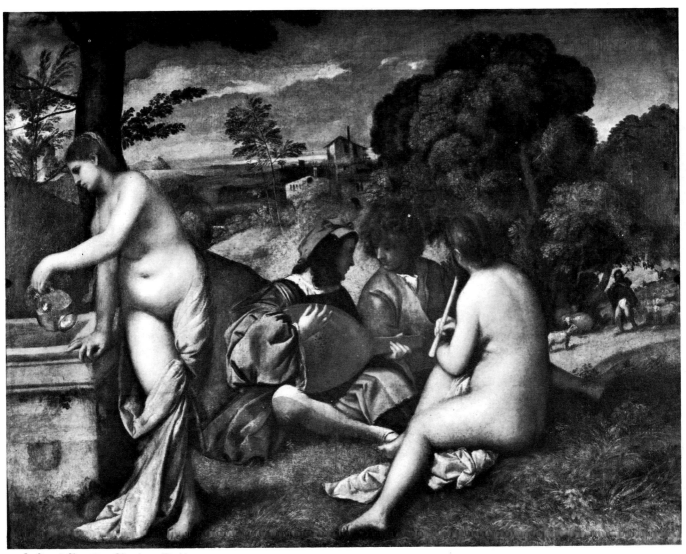

13 *Le Concert Champêtre*. Giorgione (Paris)

Some known dates in Titian's life

1508 Start of the war of the League of Cambrai, in which the Pope (Julius II) allied himself with France, Spain and the Empire to break the power of Venice on the mainland. The battle of Cadore, in which a Venetian general, Bartolomeo d'Alviano, routed the Imperial troops at Titian's birthplace in the Dolomites, was on March 2nd, 1508

1510 Death of Giorgione

1511 First documented paintings by Titian – frescoes at the Scuola del Santo, Padua
Sebastiano del Piombo moves from Venice to Rome

1512 Battle of Ravenna, in which the young French general, Gaston de Foix, is killed in his hour of victory

1516 Death of Giovanni Bellini

1517 Luther, at Wittenberg, attacks the sale of Indulgences and thereby initiates the Reformation

1518 Unveiling of Titian's altarpiece – *The Assumption of the Virgin* – at the Frari in Venice
Tintoretto born

1520 Earliest surviving picture by Titian bearing a date – *Madonna and Saints* at Ancona
Death of Raphael in Rome

1523 *Bacchus and Ariadne* finished

1527 Sack of Rome. Pietro Aretino settles in Venice

1529 Short visit by Michelangelo to Venice

1530 First meeting of Titian and the Emperor Charles V at Bologna

1533 Charles V creates Titian Count Palatine

1537 Titian paints *The Battle of Cadore* at the Doge's Palace (fresco destroyed by fire in 1577)

1543 *Ecce Homo* (Vienna) finished
First meeting of Titian and Pope Paul III at Ferrara

1545 Titian visits Rome, calling at Urbino on the way and at Florence on the way back

1547–8 Titian summoned to see Charles V at Augsburg

1548 Titian summoned to meet Prince Philip (later King Philip II of Spain) at Milan

1550 Titian again summoned to Augsburg

1554 *La Gloria* finished for Charles V

1555–6 Charles V abdicates at Brussels, and goes to the monastery of Yuste in Spain, taking with him various pictures by Titian, including *La Gloria*

1564 Death of Michelangelo in Rome
Titian agrees to paint a series of pictures for Brescia town hall

1576 Death of Titian at Venice

Notes on the illustrations

Frontispiece *Self-Portrait.* 38 × 29½ in. (96 × 75 cm.) Gemäldegalerie Berlin-Dahlem.
If the portraits of young men at Washington and London (plates 19-20) are in fact of Titian he has certainly greatly changed in the intervening years (there is no doubt that this one represents him: it may date from around 1550). Nevertheless, a feature which is common to it and them is the underhung lower jaw, which is something which would change relatively little with age and is one of the most convincing indications that the two early portraits may also represent Titian.

Figure 2 *Madonna and Child with Saints:* Giovanni Bellini. 196¾ × 92½ in. (500 × 235 cm.). Church of St. Zaccaria, Venice.
This, perhaps the grandest and the most developed of all Giovanni Bellini's altarpieces, dates from 1505. It is distinguished from its predecessors partly through the unifying effect of the light and partly through the innovation of introducing glimpses of open air and vegetation on either side of the throne.

Figure 3 *The Agony in the Garden:* Giovanni Bellini. 32 × 50 in. (81 × 127 cm.). National Gallery, London.
This picture is based on a drawing by the father of Giovanni and Gentile Bellini (Jacopo Bellini). Mantegna, who married the sister of Giovanni and Gentile, also did a painting from the same drawing which, by a curious chance, has also come to rest in the National Gallery. Both pictures, in their different ways, show early approaches to the problem of co-ordinating figures and landscapes which later exercised Giorgione and Titian.

Figure 4 *Madonna and Child with Saints:* Giorgione. 78¾ × 49¾ in. (200 × 152 cm.). Cathedral, Castelfranco.
The tradition which links this famous picture with Giorgione extends no farther back than the 17th century, but despite this, and despite the uncertainty concerning almost all the works attributed to him, this one is never doubted. It goes even farther than Giovanni Bellini's St Zaccaria altar (figure 2) by bringing the whole of the Madonna's throne out into the open air, so as to be able to introduce the maximum of landscape into the background. The early altarpieces of Titian, such as that at Santa Maria della Salute (figure 5) derive directly from Bellini

to a great extent. But the existence of works of Giorgione such as this one would have acted as intermediaries to a limited degree.

Figure 5 *St Mark with Saints Sebastian, Roch, Cosmos and Damian.* 89 × 57¾ in. (226 × 146 cm.). Church of Santa Maria della Salute, Venice.
The presence of St Roch in this work, who was invoked against the plague, makes it probable that this picture commemorates the plague of 1510 (which killed Giorgione) and dates from soon afterwards. The altarpiece consisting of an enthroned figure (the Madonna or a saint) flanked by standing saints was one in which Giovanni Bellini had excelled – as in the St Zaccaria altar (figure 2). Giorgione, too, had made a notable contribution to it in his Castelfranco altar (figure 4). In the present picture Titian owes something to both, but his picture is much simpler than Bellini's, and the forms more three-dimensional than Giorgione's (note in this connection that the carpet hangs against a flat surface in the Castelfranco picture but against a curved one here).

Figure 6 *The Feast of the Gods:* Giovanni Bellini and Titian. 67 × 74 in. (170 × 188 cm.). National Gallery of Art, Washington, D.C. (Widener Collection 1942).
This picture, as the earliest of the five bacchanals (three by Titian, one Bellini/Titian and one Dosso Dossi) which adorned the Studio of Alfonso d'Este at Ferrara, inevitably set the model for the rest in shape, size, scale of figure and subject matter. (For its earlier history see Edgar Wind's book: Bellini's *Feast of the Gods* – 1948.) It is dated 1314, when Bellini was certainly very old (as with Titian we do not know precisely when he was born). The young Titian, who may have assisted Bellini in its execution, subsequently repainted all the left background (with the precipitous rock). Bellini had spent nearly all his life painting religious subjects and this genre would have been new to him.

Figure 7 *The Marriage of St Catherine:* Paolo Veronese. 132 × 94¾ in. (337 × 241 cm.). Accademia, Venice.
Though painted within the second half of the 16th century this picture still shows the unmistakable influence of Titian's great Pesaro *Madonna* (plate 13) in its asymmetrical presentation, even though Titian's reason for evolving this system no longer applied in this case (see Introduction).

Figure 8 *The Death of St Peter Martyr:* Martino Rota (after Titian). British Museum, London.

An excellent 16th-century engraving after Titian's altarpiece in St Zanipolo, Venice, which dated from 1528-30, was destroyed by fire in 1867 and was always considered the painter's masterpiece. The painting evidently combined the dramatic quality of the great *Assumption* at the Frari (plate 11) with the landscape element lacking in that work but present in most other of Titian's characteristic paintings. Its loss at such a relatively late date must be considered one of the most tragic disasters which have yet befallen Renaissance art.

Figure 9 *St Anthony and the Youth's Leg:* Donatello. $2\frac{1}{2} \times 48\frac{1}{2}$ in. (57×123 cm.). Church of the Santo, Padua.

One of a series of brilliant bronze reliefs executed by Donatello during his stay in Padua between 1443 and 1453. It was later to exert some influence over Titian in his fresco of the same subject in the Scuola attached to the same church (plate 2).

Figure 10 *Sunset Landscape:* Giorgione. $28\frac{7}{8} \times 36$ in. ($73 \cdot 3 \times 91 \cdot 5$ cm.). National Gallery, London.

The official subject of this picture is probably the three saints, Anthony of Padua, George and Roch. But the landscape fascinated the painter to such an extent that the figures appear as quite minor elements, even St Roch, in the foreground, having his wound tended, being on a small scale in relation to the surround, while St George's fight with the dragon is relegated to the background. Nevertheless this picture, though rather extreme, shows the Giorgionesque principle of co-ordinating landscape and figures which very much affected Titian.

Figure 11 *Charles V at Mühlberg:* $76 \times 43\frac{3}{4}$ in. (193×111 cm.). Prado, Madrid.

This is one of several portraits which Titian executed of the emperor. The composition may be based on the equestrian statue of Marcus Aurelius, in Rome.

Figure 12 *Venus:* Giorgione. $42\frac{1}{2} \times 69\frac{3}{4}$ in. (108×175 cm.). Gemäldegalerie, Dresden.

It is likely that this is identical with a 16th-century reference which says that the figure of Venus was painted by Giorgione but parts of the background added by Titian (presumably after Giorgione's premature death). The total nudity (i.e. without jewelry) of Giorgione's Venus, and the fact that she is asleep and not looking at the spectator, lends her a more distant, more goddess-like quality than Titian saw fit to employ (see his *Venus of Urbino*, plate 18).

Figure 13 *Le Concert Champêtre:* Giorgione. $34\frac{1}{3} \times 54\frac{1}{3}$ in. (110×138 cm.). Louvre, Paris.

This is one of the most bitterly disputed of the Giorgionesque pictures, opinion being almost equally divided as between Giorgione and Titian, with perhaps a narrow majority favouring the former. In any case it represents the quintessence of the Giorgionesque in its coordination of figures and landscape and its dreamy, almost inexplicable subject. Early works indubitably by Titian, such as the *Three Ages of Man*, the *Noli me Tangere* or the *Sacred and Profane Love* (plates 3-8) represent the developments which he made from this type of picture.

THE COLOUR PLATES
Unless otherwise stated the paintings here reproduced are oils on canvas.

Plate 1 *Pope Alexander VI presents Jacopo Pesaro to St Peter.* $57\frac{1}{4} \times 72\frac{1}{2}$ in. (145×183 cm.). Musée des Beaux-Arts, Antwerp.

Jacopo Pesaro, Bishop of Paphos, had won a naval victory over the Turks in 1502, in the capacity both of admiral and papal commissioner. The fact that the Pope in question was Rodrigo Borgia has suggested to some critics that the picture was unlikely to have been painted after his death in the following year (1503) on account of the hatred which was subsequently felt for him. Though this argument might have some force in respect of the inhabitants of Rome, it would be likely to be less cogent as regards a city as far away as Venice. In point of fact the style of most of this picture is little more primitive than that of the early Salute altar of about 1510 (figure 5) and therefore probably dates from not so long before it. But there would be a possibility of an interruption in the execution, since the stiff folds of St Peter's draperies do seem less mature than those of the other two figures. The inscription records the occasion commemorated, but may not be original.

Plate 2 *St Anthony Healing the Youth's Leg.* Fresco. Scuola del Santo, Padua.

One of a set of wall paintings which are Titian's earliest precisely dated works (1511) and also among his very rare surviv-

ing frescoes. The design is based to some extent on that of Donatello's relief of the same subject in the nearby Church of the Santo (figure 9). This origin is noticeable in the way in which the painted figures are treated as in a relief, with little recession into the background, which itself has something of the effect of a drop curtain.

Plate 3 *The Three Ages of Man.* 42 × 72 in. (106 × 182 cm.). Duke of Sutherland Collection, on loan to the National Gallery of Scotland, Edinburgh.
One of Titian's most beautiful essays in the Giorgionesque, probably painted a year or two after Giorgione's death in 1510. The dreamy mood of the figures is echoed in the landscape. The young lovers – representing the prime of life, the best time in it – are given the most space. Infancy, on the right, has less, and less still is allotted to old age, brooding in the background on the vanity of human life, with a skull in his hand, and prophetically looking like Titian himself was to look some sixty years later. Since the recent cleaning of this picture much of the brilliance of the colours has reappeared.

Plate 4 *The Baptism of Christ.* 45½ × 35 in. (115 × 89 cm.). Pinacoteca Capitolina, Rome.
The Baptist, on the left, is evidently the same youth as the model for the one in the same relative position in *The Three Ages of Man* (plate 3) and the type of landscape is also similar. In consequence it is hardly surprising that the lyrical mood of the two pictures is much the same, despite the great difference in the type of subject. The basic idiom is still Giorgionesque, but the cherubs' heads in the sky are already fully characteristic of Titian.

Plate 5 *Noli me Tangere.* 42¾ × 35¾ in. (109 × 91 cm.). National Gallery, London.
Another and perhaps even more beautiful essay in the Giorgionesque, dating, in all probability, from slightly later than the *Three Ages* (plate 3), and showing that the lyrical combination of figures and landscape is as applicable to religious subjects as to secular ones. X-ray photographs show that Titian made many alterations during the course of painting this picture and at some time after his death part of Mary Magdalene's dress was deliberately overpainted to make her appear slimmer. This repaint was removed when the picture was cleaned a few years ago. The paint now seems well preserved, though some of the green pigment has oxydised to brown.

Plates 6, 7 & 8 *Sacred and Profane Love.* 46¾ × 111 in. (118 × 279 cm.). Villa Borghese, Rome.
Probably the most famous, and quite possibly also the most beautiful, of all Titian's early pictures in the Giorgionesque manner. The bas relief on the tomb in the centre recalls St Peter's throne in the very early picture now at Antwerp (plate 1) but the treatment here is more assured. All kinds of romantic and fanciful explanation of the subject have been attempted, but none of them has been universally accepted. It will be noticed that the scale of the figures here is larger in relation to the frame than in the *Noli me Tangere* (plate 5) or the *Three Ages* (plate 3) and this seems to indicate that Titian was growing out of his Giorgionesque phase when this picture was painted and moving towards the more monumental style of his first maturity.

Plate 9 *The Gipsy Madonna.* 25½ × 32½ in. (68·8 × 83·5 cm.). Kunsthistorisches Museum, Vienna.
Though not signed or documented as Titian, this picture is always regarded as his work and as an important item of evidence in trying to distinguish his early work from Giorgione's late work. Superficially, it is very like a group of pictures which centre round the Castelfranco *Madonna* (figure 4). The main difference of treatment is that Titian's forms are more three-dimensional and the outlines correspondingly less subtle. The folds of drapery, for instance, round the Virgin's right wrist look almost as though they were inflated. The popular name for the picture may derive from the hanging behind the Madonna.

Plate 10 *Madonna with the Cherries.* 31¼ × 39⅜ in. (81 × 99·5 cm.). Kunsthistorisches Museum, Vienna.
Though neither picture is dated this one must date from after the *Gipsy Madonna* (plate 9) since in it Titian has moved nearer to his mature style. The Madonna is already almost of the type we shall see in the great *Assumption* of the Frari (plate 11). The composition is built up on a system of diagonals, set off by the vertical of the brocade curtain in the background; and the Madonna's averted glance, over her right shoulder, is also

characteristic (compare that of the nude woman, on the right of the *Sacred and Profane Love* (plate 6)).

Plates 11 & 12 *The Assumption of the Virgin.* 272 × 142 in. 270 cm.). Church of the Frari, Venice.
The traditional type of representation of the Assumption of the Virgin had usually shown the scene in a relatively calm atmosphere, the Virgin herself, in particular, having been depicted with her hands gently folded in prayer. The first to depart from tradition to the extent of showing the Madonna with her arms outstretched seems to have been Mantegna (in a 15th century fresco at Padua). Titian would have been acquainted with Mantegna's work and was evidently affected by it. But not even Mantegna had shown quite the degree of dynamism and agitation which Titian gives his Apostles, while the scale of the whole and the splendour of the colours of the Titian were also without precedent.

Plate 13 *Madonna of the Pesaro Family.* 191 × 106½ in. (485 × (485 × 270 cm.). Church of the Frari, Venice.
This great picture was painted between 1519 and 1526 for Jacopo Pesaro, Bishop of Paphos. He is shown kneeling on the left and is clearly recognisable from Titian's earlier portrait of him in the Antwerp picture (plate 1). Observations made from a ladder in the 19th century showed that the background of the present picture was originally a coffered barrel vault instead of the two huge pillars. The revolutionary asymmetry of this picture is described in the Introduction.

Plate 14 *St Sebastian.* 66 × 28 in. (167 × 63 cm.). Church of SS. Nazaro and Celso, Brescia.
This is a panel from a composite altar, or polyptych. The fact that it was this piece of it which Titian elected to sign and date (1522) – a fairly rare occurrence with him – shows that he himself had a high regard for it, and this is confirmed by the existence of several preparatory drawings – an even rarer event. As on a later occasion – the *Venus and Adonis* (plate 39) – he seems to have gone to enormous trouble to indulge in more elaborate and difficult draughtsmanship than usual – perhaps in answer to criticism of this branch of his art. It has been suggested, too, that he drew some inspiration from the famous antique sculpture of the *Laocoön*, as he also did in the *Bacchus*

and Ariadne (plate 16) and in the earlier version of the *Christ Crowned with Thorns* (plate 37).

Plate 15 *Bacchanal of the Andrians.* 69 × 76 in. (175 × 193 cm.). Prado, Madrid.
Another of the bacchanals (see figure 7, the Bellini/Titian *Feast of the Gods*) for Alfonso of Ferrara. Judging by the number of old copies it was even more admired in the 17th and 18th centuries than the *Bacchus and Ariadne* (plate 16). In this case the subject comes from Philostratus who describes the river of wine on the island of Andros and how the Andrians have become drunk through drinking it. Though Titian himself had not been to Rome when he painted this picture, he was evidently acquainted through drawings with various antique sculptures and worked adaptations of them (for instance, the sleeping nymph in the foreground) into the picture.

Plate 16 *Bacchus and Ariadne.* 69 × 75 in. (175 × 190 cm.). National Gallery, London.
This is another of the bacchanals painted by Titian for Alfonso I, Duke of Ferrara. The model was Giovanni Bellini's *Feast of the Gods* (figure 6) which had been the first, and of which Titian later repainted part of the landscape. The present picture dates in essentials from 1522-3 and was destined like the others for a small room in the castle of Ferrara, which the Duke called his Studio. Titian's bacchanals are the masterpieces of his earlier work in a secular sphere. The Duke took an active interest in the work and supplied the painter with texts from classical authors (in this case Catullus and Ovid). In the present picture Ariadne, on the left, wanders dejectedly by the shore after being abandoned by Theseus. Here she is discovered by Bacchus and his rowdy followers.

Plate 17 *The Entombment of Christ.* 58¾ × 84¾ in. (148 × 218 cm.). Louvre, Paris.
This splendidly moving work was painted for the Gonzaga court at Mantua some time in the 1520s and later belonged to Charles I of England. Like Raphael's famous picture in the Borghese Gallery, Rome, the subject is a procession to the tomb rather than an Entombment in the strict sense. As Bellini had done, Titian invokes help from the lighting and the landscape to heighten the mood of the drama. This lends dramatic con-

trast to the marvellously painted striped satin shirt of the bearer behind Christ and enhances the romantic head of St John in the centre.

Plate 18 *Venus of Urbino*. $64\frac{3}{4} \times 76\frac{1}{2}$ in. (165×195 cm.). Uffizi, Florence.
This picture was one of many executed for Francesco Maria della Rovere, Duke of Urbino, which explains its name. The pose which Titian uses here clearly derives from Giorgione's *Venus* of some thirty years earlier (figure 12). The present picture is mentioned in correspondence of 1538 and was presumably finished then. Titian's Venus is more 'naked' and less 'nude' than Giorgione's. The domestic background (instead of landscape) and the accessories such as earrings and bracelet – to say nothing of pillows and bedclothes – make this clear. Nevertheless, we have only to compare the result with Manet's *Olympia* (Louvre) to see that Titian has not gone the whole way. The treatment of the body is generalised both in its outlines and its modelling and in this way maintains a certain classical feeling for all its realistic·trappings.

Plate 19 *Portrait of a Venetian Gentleman*. $29\frac{3}{4} \times 24\frac{7}{8}$ in. (76×63 cm.). National Gallery of Art (Samuel H. Kress Collection), Washington, D.C. The development of the portrait from the small head and shoulders – as had been normal in the later 15th century – to the half – and finally full-length was one of the most important innovations in 16th-century painting, and a very great deal of the credit is due to Titian. Late portraits by Giovanni Bellini, such as the *Doge Loredan* or the *Fra Teodoro* (both in the National Gallery, London), already show the sitter behind a ledge, as here, and thus introduce an effect of recession. Giorgione, too, had extended the principle in works such as his *Portrait of a Youth* now at Berlin. In the present picture Titian shows a still greater area of surround and introduces a recognisable representation of the Doge's Palace, Venice. So thin a growth of beard and moustache in so dark a man suggests that the sitter was still in his teens and the direction of the eyes unmistakably suggests a self-portrait.

Plate 20 *Portrait of a Man*. 32×26 in. ($81·2 \times 66·3$ cm.). National Gallery, London.
Though the nose appears a little straighter than in the Washing-

ton portrait (plate 19) the direction of the eyes again suggest a self-portrait, perhaps painted some five years later, during which time the sitter has shaken off most of his rustic uncouthness and acquired a certain degree of polish. Though in neither case is it possible to prove a self-portrait it is significant that the present picture is acknowledged to have been the pictorial source of one of Rembrandt's self-portraits (also now in the National Gallery).

Plate 21 *Portrait of a Young Man*. $39\frac{1}{2} \times 33$ in. (100×84 cm.). Earl of Halifax, Garrowby Hall, York.
Nothing is known of the sitter for this portrait, and the picture itself has often been attributed to Giorgione and other painters. There nevertheless seems no legitimate reason to doubt that it is a Titian of around 1520, an unusually fine example of the half-length and one in which a certain lyric quality, associated with the Giorgionesque phase of Titian's youth, has coloured the reflective features of the young sitter.

Plate 22 *Portrait of a Young Man*. 44×37 in. (111×93 cm.). Palazzo Pitti, Florence.
This portrait is sometimes called the 'young Englishman' or the 'Duke of Norfolk' but in fact the identity of the sitter is not known and there is no known date of execution. For a painter such as Titian, whose chief claim to fame has always been the splendour of his colouring, this may come as a surprise. It has no bright colours, only sombre greys and blacks. But it is obviously a masterpiece of portraiture. The sitter, a young man who looks as though he would be happier doing something active, comes to life with extraordinary vividness.

Plate 23 *Portrait of Pietro Aretino*. $39\frac{1}{4} \times 32$ in. (99×82 cm.). Frick Collection, New York.
Years of good living and the indulgence of every sensual appetite had turned the notorious but very lively writer and blackmailer into the bloated image we see here. The strongly marked features contribute to the general impression of repulsive power. It seems at first surprising that Titian should have been a close friend of such a person. The explanation is that Aretino was very good company, that he flattered Titian and that he brought him clients. The picture must date from the 1540s.

Plate 24 *The Vendramin Family*. 81 × 118½ in. (206 × 301 cm.). National Gallery, London.

The picture was once wider, and it is still possible to see on the extreme left the ghostly profile (showing through the sky) of the young bearded man who now appears slightly nearer the right. Titian evidently changed this at a relatively early stage. The old man kneeling in the centre is Gabriel Vendramin, a rich merchant and collector of works of art. His brother, Andrea, in a red velvet robe, stands to the spectator's left of him. The other figures are Andrea's seven sons. His six daughters are not included. The cross on the altar is a reliquary of the True Cross which still exists and had once been saved from falling into the canal by a member of the Vendramin family. So large a family group was not common in Renaissance portraiture, and there is no other Titian which is comparable. It dates from the 1540s.

Plates 25 & 26 *The Presentation of the Virgin* 136 × 295 in. (345 × 775 cm.). Accademia, Venice.

Though painted (in the mid-1530s) on canvas, this huge picture was always intended for the wall it now occupies, and allowance was made for its peculiarities, at least in respect of the door on the right. At that time the building was called the Scuola della Carita and was one of the characteristic Venetian benevolent societies. Through being on canvas, the colours, particularly the youthful Virgin's blue dress, are richer and more glowing than would have been possible in fresco, but although the result has many beauties and is one of Titian's largest works, the difficulties of the site have perhaps prevented its being among his greatest.

Plate 27 *Portrait of Pope Paul III*. 42 × 32 in. (106 × 82 cm.). Capodimonte Gallery, Naples.

Raphael had been the first – in his portrait of Julius II – to show a pope seated diagonally to the spectator, and this subsequently became general for papal portraits. The present picture was painted when Paul III visited Ferrara and Bologna in 1543. Vasari relates that when it, or another of Titian's portraits of the Pope, was placed at an open window to dry the varnish the people in the neighbourhood bowed, mistaking the semblance for the reality. Though similar stories have been told at many times since antiquity they at least indicate that the work was inordinately admired at the time.

Plate 28 *Portrait of Pope Paul III and his 'Nipoti'*. 83 × 68¾ in. (210 × 174 cm.). Capodimonte Gallery, Naples.

This was painted in Rome when Titian was there in 1545/6. The Italian word 'nipote' conveniently means either nephew or grandson. In the present case it was the latter. This famous portrait group was never finished – perhaps because it was realised that the family quarrel which is so obviously taking place was rather too revealing for the comfort of the Farnese papal family. Paul III was at this time seventy-eight years old. He is known to have spoken very softly, which is why Ottavio Farnese, on the right, stoops to him. On the left is Cardinal Alessandro Farnese. The discovery that these two were plotting against the Pope hastened his death a few years later.

Plate 29 *Portrait of Philip II of Spain in Armour*. 76 × 44 in. (193 × 111 cm.). Prado, Madrid.

The full-length pose not only gives more space for the display of adjuncts (the whole of Philip's helmet, for example) but also completes the image of the sitter. In this case it would have been a pity to omit Philip's elegant legs. The armour is brilliantly painted. This is probably the picture referred to in the Introduction: Philip, not appreciating Titian's semi-impressionist technique, said he thought the picture looked hastily painted.

Plates 30, 31 & 32 *La Gloria*. 136¾ × 95 in. (346 × 240 cm.). Prado, Madrid.

This is the most important of Titian's later altarpieces. The subject is the Emperor Charles V and his family (portrayed on the upper right hand side) supplicating the Trinity. Old Testament figures – including Noah with the Ark and Moses with the Tables of the Law – are shown in the left foreground. There may be some influence from Michelangelo's *Last Judgment* and from Dürer's *Allerheiligenbild* (now at Vienna). The Emperor took this picture with him to Spain when he abdicated in 1556/7.

Plates 33, 34, 35 *Ecce Homo*. 95 × 142 in. (240 × 360 cm.). Kunsthistorisches Museum, Vienna.

This picture, dated 1543, was painted for a Flemish merchant, Jan van Haanen, then living in Venice. The general composition was clearly developed from that of *The Presentation of the Virgin* (plate 26) of a few years earlier. But as befits its subject,

it is far more dramatic in effect. In the meantime, also, Titian's technique had become more summary. The figure of Pilate is known to be a portrait of Pietro Aretino. It has been suggested that some of the other figures are portraits, but there is no authority for this.

Plate 36 *St Jerome.* 93 × 49¼ in. (235 × 125 cm.). Brera, Milan.
In an earlier, oblong, version of the same subject, now in the Louvre, Titian had shown a larger area of landscape round the saint. The greater concentration made possible by the upright format in the present case increases the importance of the figure, but landscape and saint are still closely related. Something of the fiery quality of the aged figure, for instance, seems reflected in the agitation of the trees. Certainly the picture is a late work and the saint may well incorporate a degree of self-portraiture.

Plate 37 *Christ Crowned with Thorns.* 119 × 70¾ in. (303 × 180 cm.). Louvre, Paris.
This was painted for the Church of Santa Maria delle Grazie at Milan (where Leonardo's *Last Supper* adorns the refectory), probably in the 1540s. The vicious energy of the torturers and the angular patterns made by their staves may be due to influence from Dürer's prints, and Christ's expression and his upraised eyes have been thought to reflect something of the influence of the *Laocoön*, the Antique sculpture group of which Titian did a caricature. In any event, the result has an unusually melodramatic quality (for Titian) and is perhaps less in accord with present-day taste than the later (Munich) version.

Plate 38 *Danäe* 50½ × 70 in. (128 × 178 cm.). Prado, Madrid.
This was among the first of a series to be painted for the young King (then Prince) Philip II of Spain in 1554. It is based on an earlier picture by Titian of the same subject (now at Naples) which is said to have been seen by Michelangelo when Titian was at work on it in Rome in 1545/6. Michelangelo criticised the draughtsmanship, despite the fact that the inspiration of the figure clearly comes from some of his own sculptures (the reclining figures in the Medici Chapel in Florence). In the present picture, note in particular the beauty of the crumpled sheet.

Plate 39 *Venus and Adonis.* 73½ × 81¾ in. (186 × 207 cm.). Prado, Madrid.
Another of the early works painted for Philip II (1554), this is also based on a design worked out by Titian during his stay in Rome (1545/6). Venus is trying to restrain Adonis, who rushes past her on his way to the hunt after a night of love. As though to rebut allegations of his bad draughtsmanship Titian evidently took unusual pains with the design. But Venus's gymnastic pose, which Florentine Mannerists, such as Bronzino, could have handled effectively, looks a little awkward in Titian's hands and foreign to his nature. Various other versions of this picture exist.

Plates 40 & 41 *Diana and Actaeon.* 75 × 81¾ in. (190·5 × 207 cm.). Duke of Sutherland Collection, on loan to the National Gallery of Scotland, Edinburgh.
Actaeon, while hunting, came unexpectedly upon Diana bathing with her nymphs. The pride of the goddess of chastity was rudely offended through being seen naked by a man. By transforming Actaeon then and there into a stag she ensured his speedy death through the agency of his own hounds. Even Titian never surpassed the beauty and delicacy of the painting of the cloth on which Diana reclines or the dress of her maid.

Plates 42 & 43 *Diana and Callisto.* 75 × 81¾ in. (190·5 × 207 cm.). Duke of Sutherland Collection, on loan to the National Gallery of Scotland, Edinburgh.
This time Diana's wrath is turned against one of her maids, who, though bound to chastity, suddenly astounds and scandalises the goddess through being seen to be in labour. Despite the appearance of the nymph on the left (who looks as though she might easily be in a similar condition herself) it is the girl on the ground who is the errant nymph, Callisto. When this picture was cleaned some forty years ago the damages in Diana's face and elsewhere were not restored, though they could have been. In consequence the picture seems relatively more damaged.

Plate 44 *The Rape of Europa.* 64¼ × 80¾ in. (176 × 204 cm.). Isabella Stewart Gardner Museum, Boston, Mass.
The painting of Europa (who was forcibly abducted by Jupiter, disguised as a bull, and taken to Crete) is the most dramatic of the poesie series painted for King Philip, and one of the best preserved. Though the perspective of the sea is a little difficult

to relate to reality, the general effect resulting from the contrast of the blues of the sky and the fiery red of Europa's cloak is almost overwhelming.

Plate 45 *The Rape of Lucretia.* $74\frac{1}{8} \times 57\frac{1}{2}$ in. ($187 \cdot 5 \times 145$ cm.). Fitzwilliam Museum, Cambridge.

This picture, dating from as late as 1571, is another scene of violence painted for King Philip; this time a subject from Roman history. Titian's draughtsmanship, which occasionally betrays him, has done so rather markedly in this case as regards Tarquin's right leg. But we may not notice this in view of the splendour of his crimson velvet breeches and the delicacy of the creases on the white sheets, where Titian's brush seems to wallow in the pigment. He may also have kneaded it with his fingers.

Plate 46 *The Education of Cupid.* $46\frac{3}{4} \times 73$ in. (118×185 cm.). Villa Borghese, Rome.

This is a late work which, unlike most from that period, was probably not intended for Philip II of Spain (there is no evidence that it was ever there: it turns up for the first time, as early as 1613, in the possession of the Borghese family in Rome). Venus binds the eyes of Cupid, watched by two nymphs. The approach to classical themes in this case is much more domestic than in the bacchanals of Titian's youth (see plates 15 and 16). Indeed, the arrangement of the picture into half lengths is not at all unlike the type evolved by Titian and others for depictions of the Holy Family.

Plate 47 *Nymph and Shepherd.* 56×74 in. (142×187 cm.). Kunsthistorisches Museum, Vienna.

This picture is clearly very late indeed. The subject seems a throwback of some sixty years to the Giorgionesque themes of Titian's youth. But the handling of the paint – tremendously rough, summary and violent – and the avoidance of local colours in favour of related tones finally produce a totally different effect. In the 18th century, when high finish was much admired, little attention was paid to this picture. But with the revulsion against what seems over-finished or over-polished, this work, in common with other productions of Titian's extreme old age, has come to be admired and revered as much as any of his pictures, or more.

Plate 48 *The Entombment of Christ.* 54×69 in. (137×175 cm.). Prado, Madrid.

This picture may be compared with the one of similar subject in the Louvre (plate 17) painted many years earlier. As in the comparison of the earlier and later *Christ crowned with Thorns* (plates 37 and 50) the later version is more summary in handling and more pathetic in emotional content. Rather less play is made in this version with facial expression and more through the contrast of the colours. The old man behind Christ resembles Titian himself.

Plate 49 *The Annunciation.* 162×105 in. (410×240 cm.). Church of San Salvatore, Venice.

A typical – though exceptionally fine – late work in its combination of dark, glowing tones, avoidance of bright colours, summary handling and general sense of urgency. The forms of the cherubim overhead are similar to those in the great *Assumption* of many years earlier (plate 11) but very different in handling. In Titian's other depictions of the subject, the Virgin is normally shown with hands crossed on her bosom.

Plate 50 *Christ Crowned with Thorns.* $110\frac{1}{2} \times 72$ in. (280×182 cm.). Alte Pinakothek, Munich.

This makes a fascinating contrast with the earlier version (plate 37). Here, in his extreme old age (as so often the exact date is not known) Titian's technique has become more summary, but is far from feeble. On the contrary, the flares – which are not in the Louvre picture – heighten the drama of the scene and diminish the melodrama. The difference is most clearly seen in the Christ, who no longer rolls his eyes but lowers them in resignation while the colours are darker and the mood more poignant.

Plate 51 *Portrait of Jacopo Strada.* $52 \times 37\frac{1}{3}$ in. (125×95 cm.). Kunsthistorisches Museum, Vienna.

The picture is datable to 1567/8 – within eight years of Titian's death. It is an unusually elaborate example of his late style in portraiture. The sitter was an art dealer, here seen with some of his wares – two statuettes and some coins. The diagonal pattern, Titian's favourite compositional device throughout his life, is retained – the zigzags of the arms of the sitter and the statuette are anchored by the verticals of the cupboards behind.

And great play is made with the different colours and textures of the white fur, red satin, blue velvet and white marble.

Plate 52 *Pietà.* 138¾ × 153¾ in. (351 × 389 cm.). Accademia, Venice.
Painted by Titian for his own tomb and completed after his death by Palma Giovane. The old man – Joseph of Arimathea or Nicodemus – kneeling on the right has always been supposed to be a self-portrait in Titian's extremest old age. The joins in the canvas suggest that this picture was originally intended to be much smaller – merely the area round the body of Christ. The figure of Mary Magdalene – one of the most vital and fiery Titian ever painted – and most of the background architecture and sculpture would have been an afterthought.

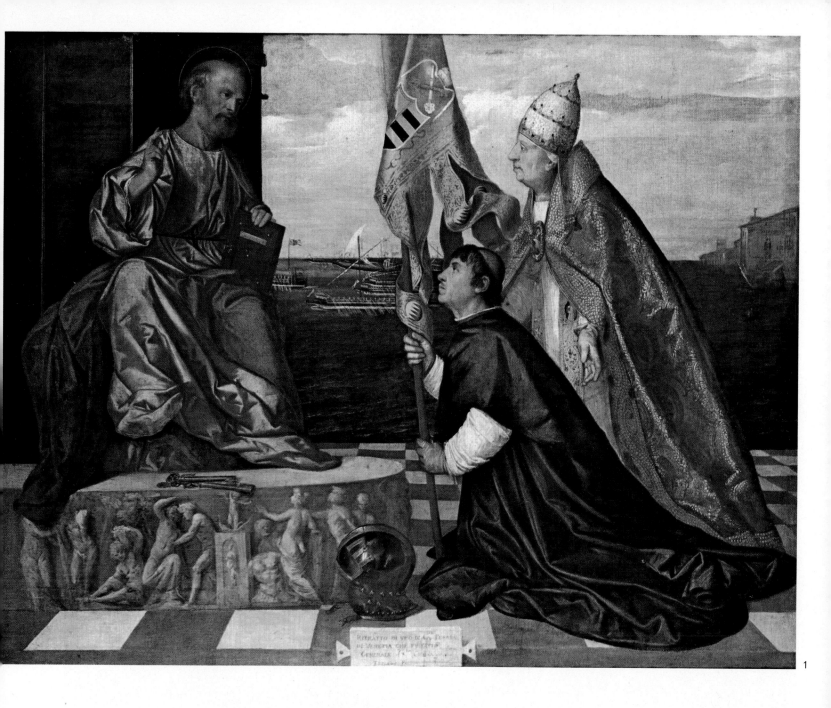

1

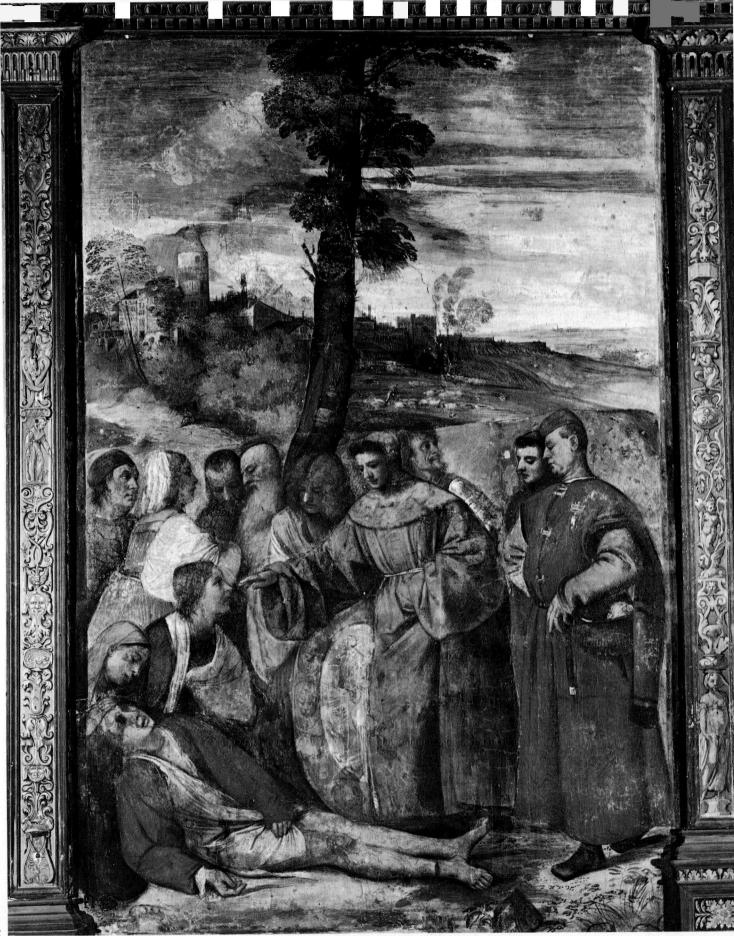

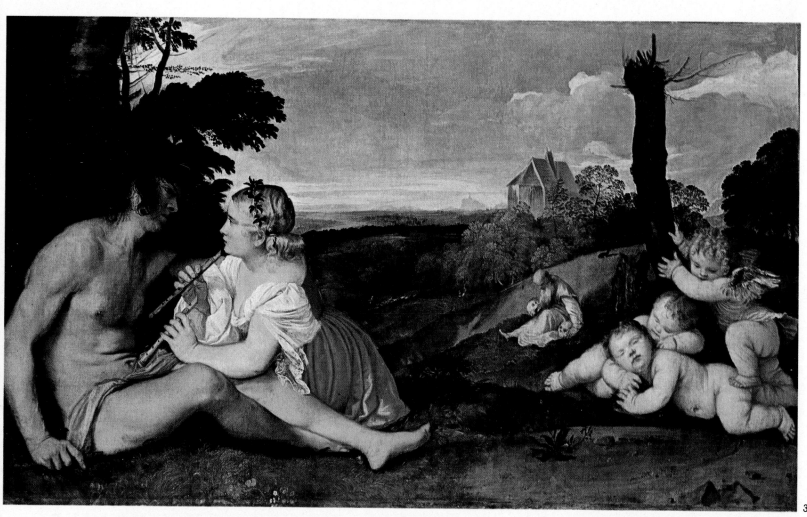

3

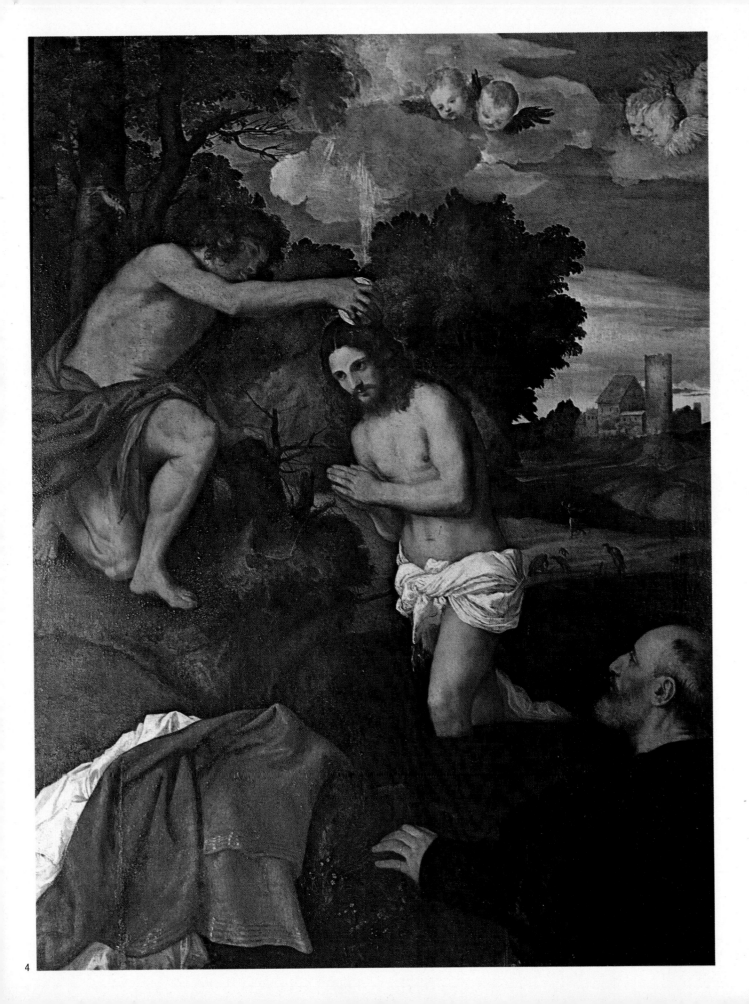

4

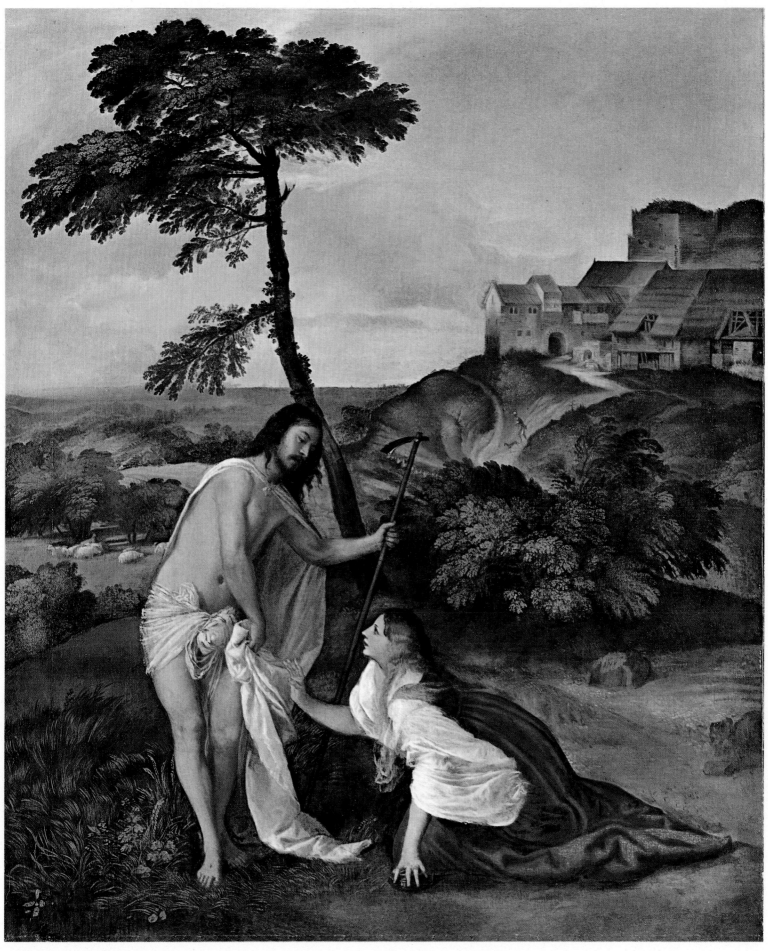

5

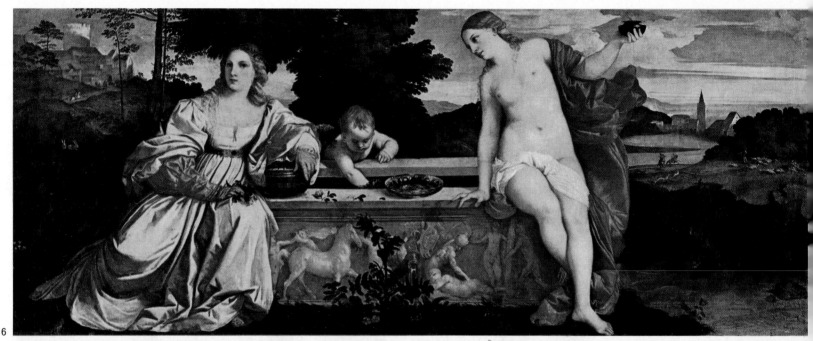

6

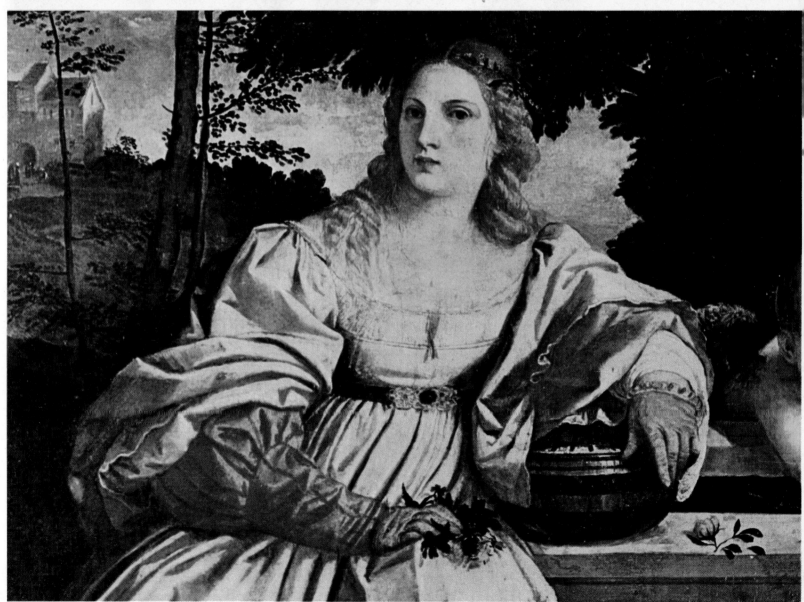

7

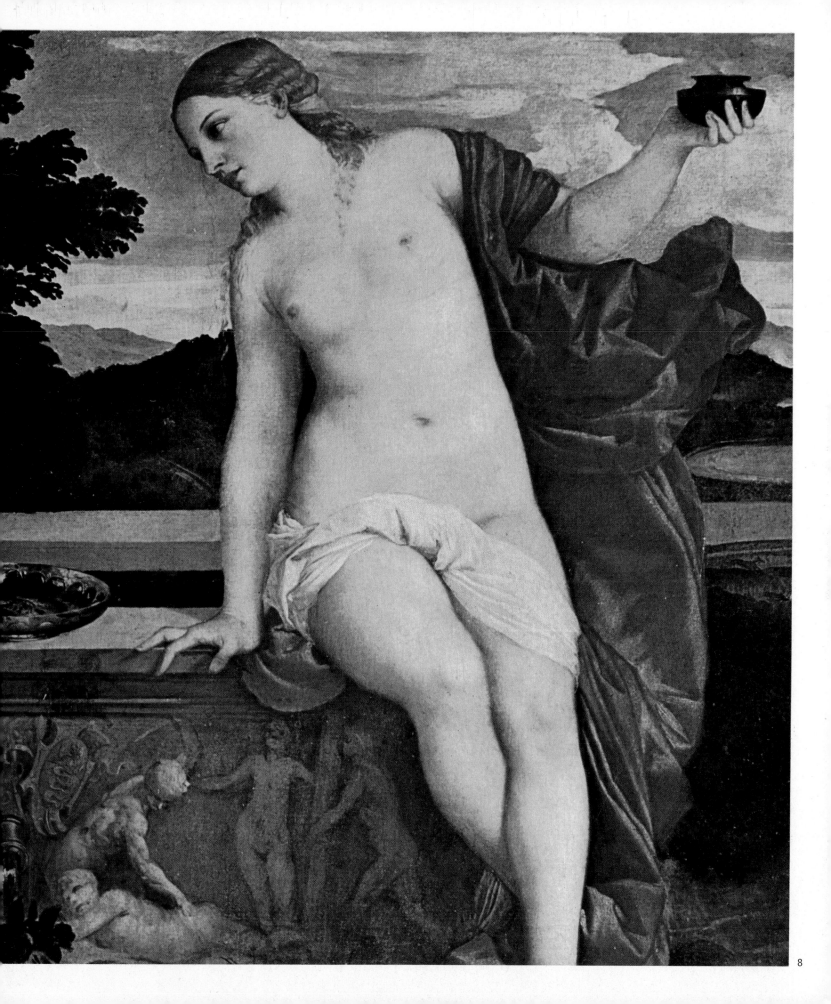

8

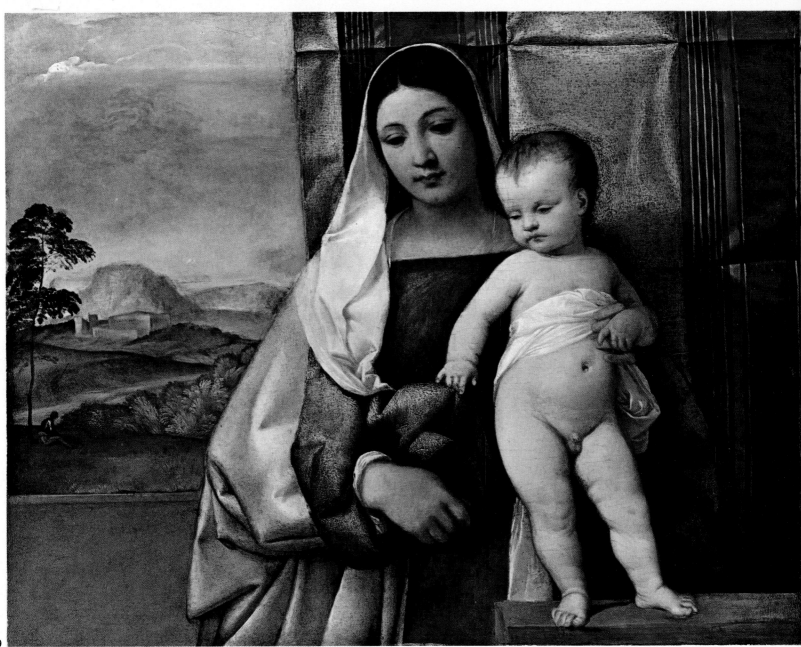

9

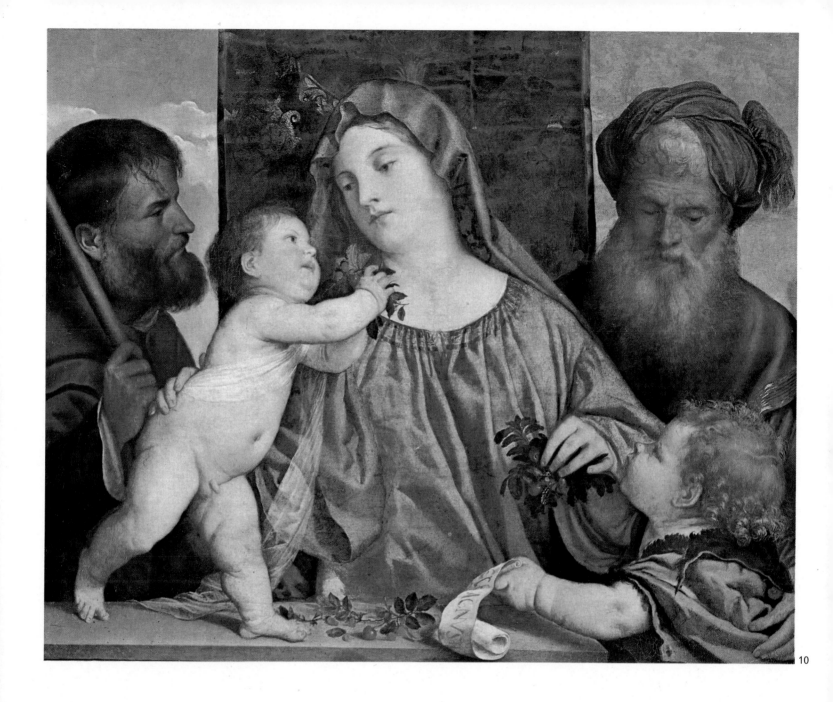

10

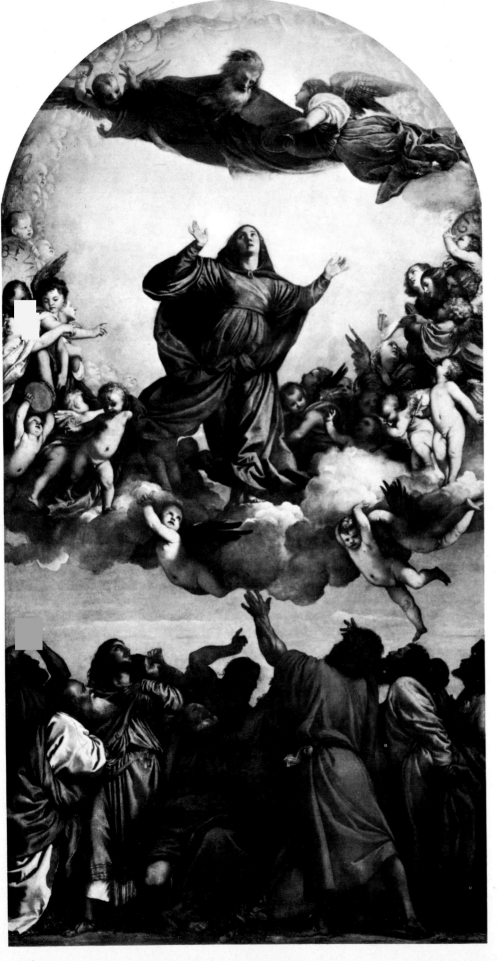

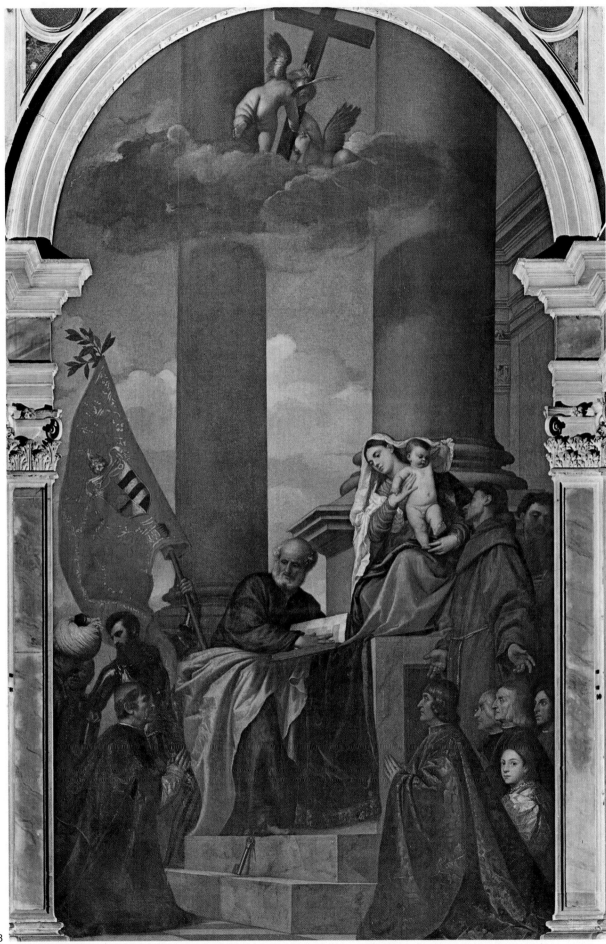

13

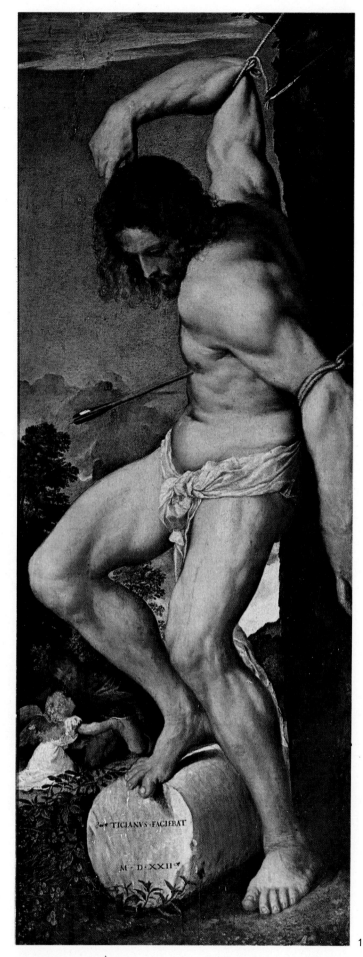

14

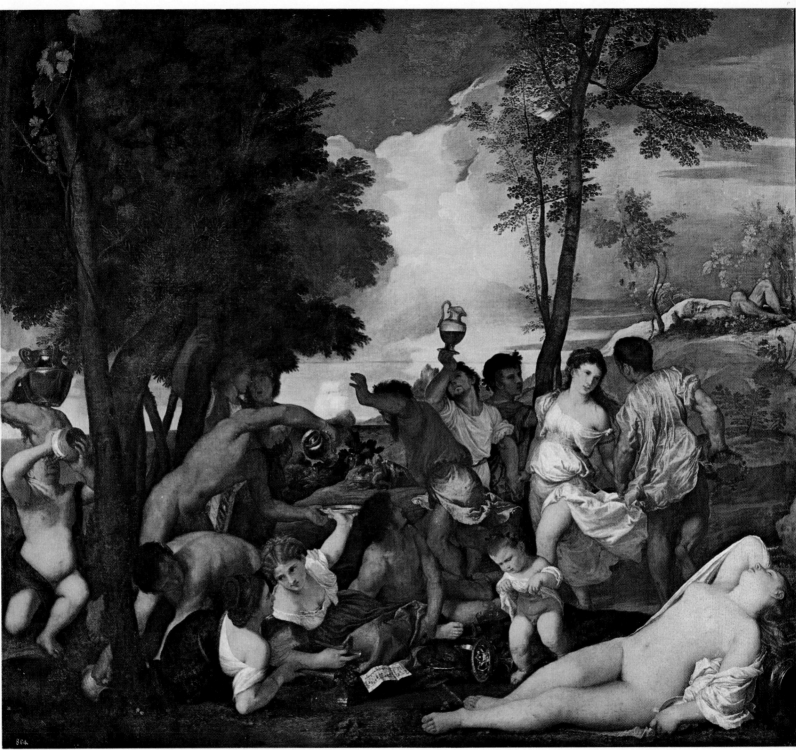

15

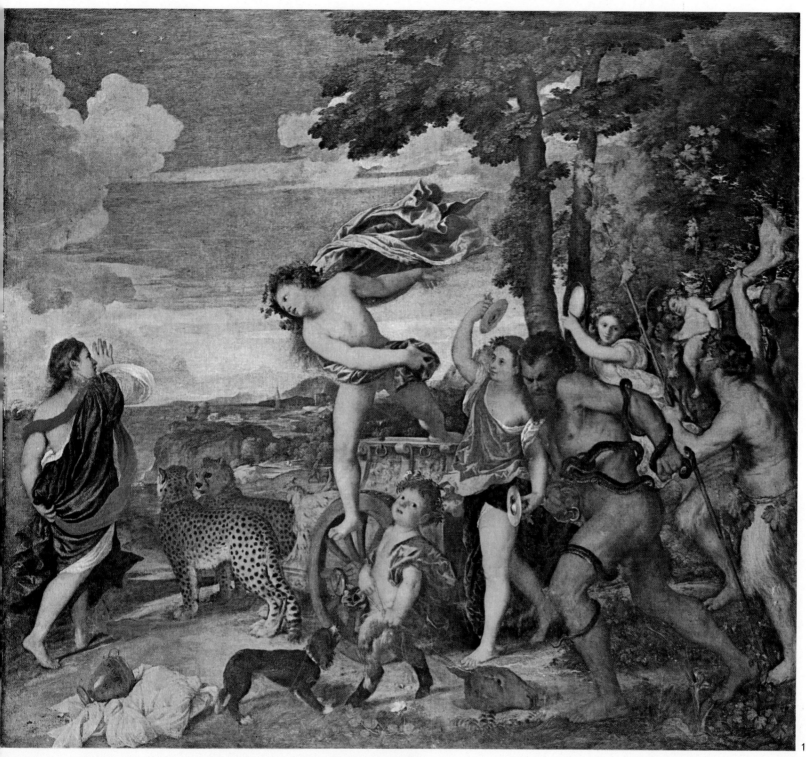

16

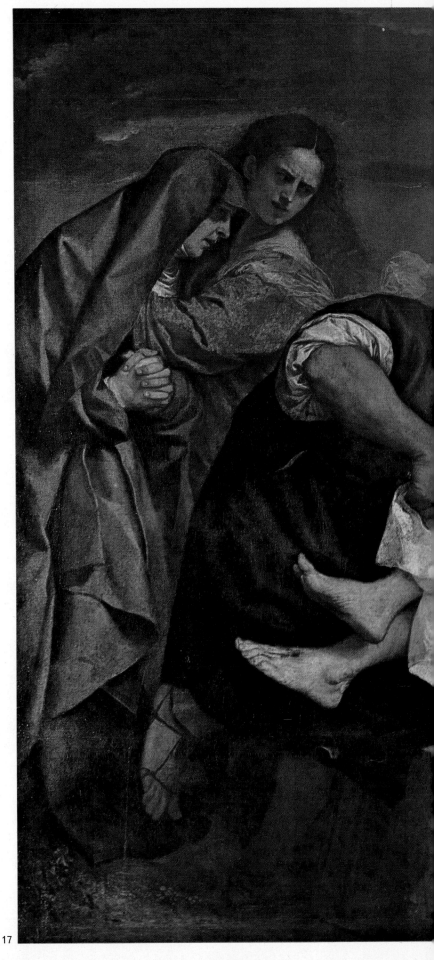

17

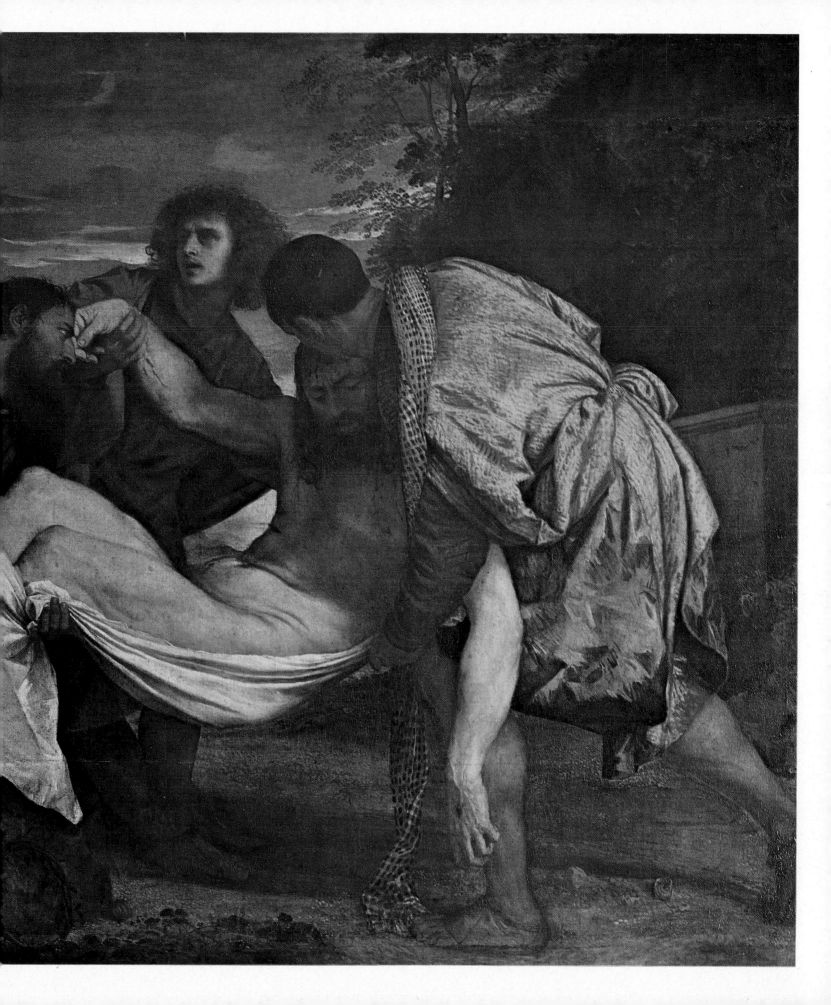

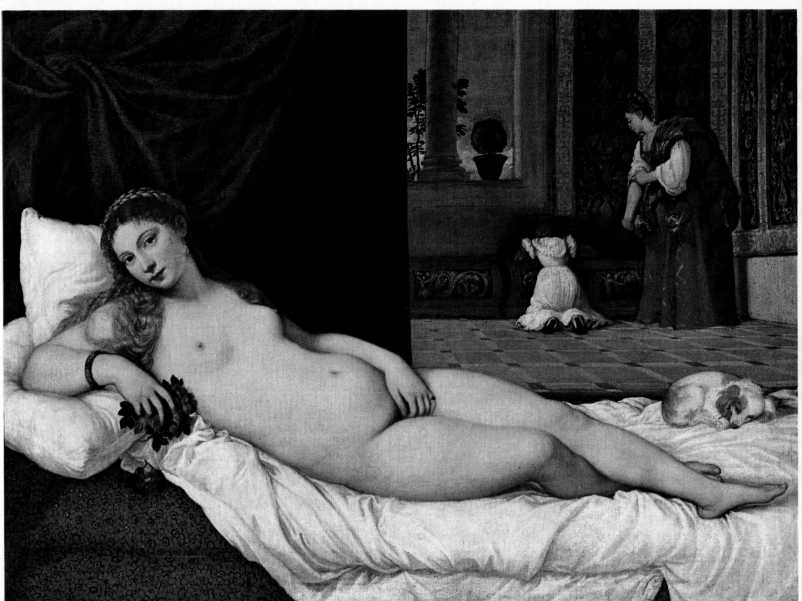

18

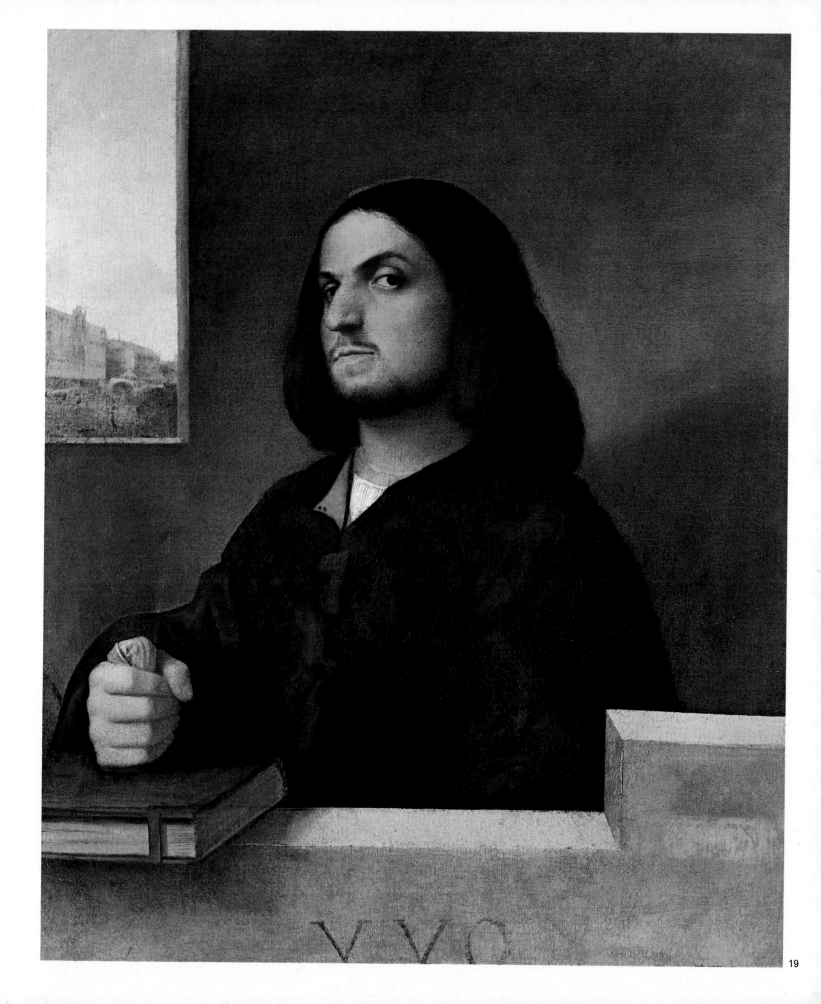

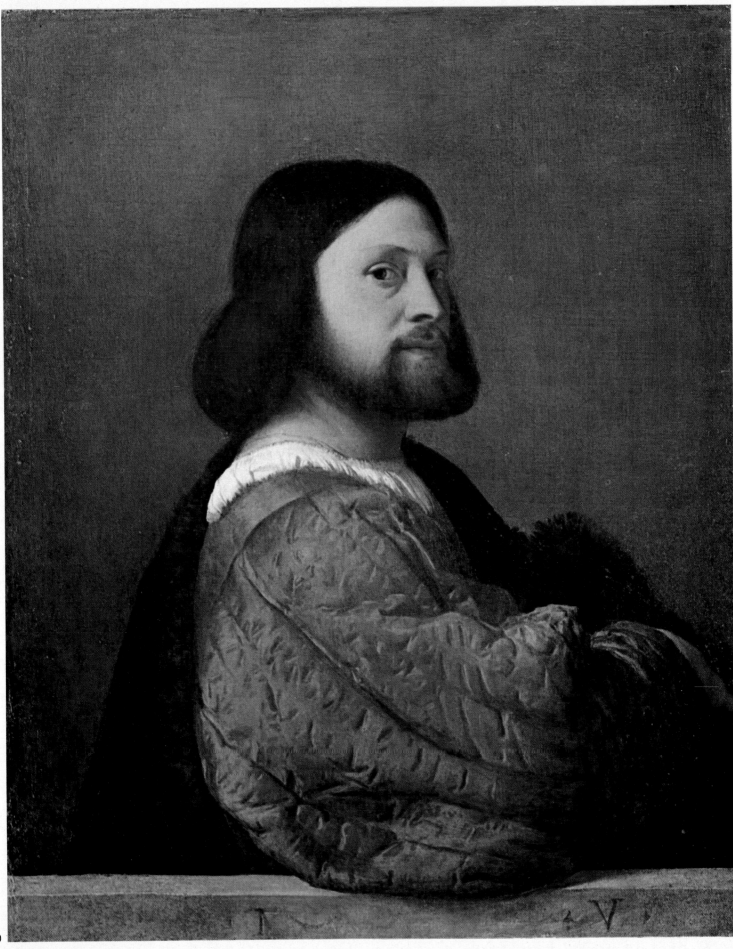

20

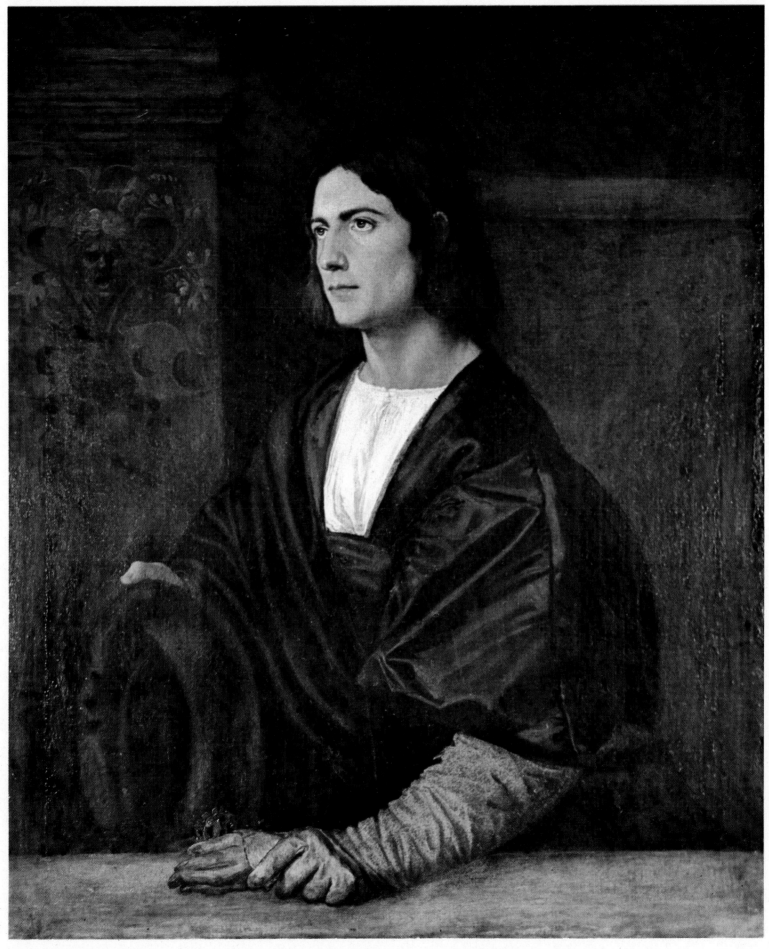

22

23

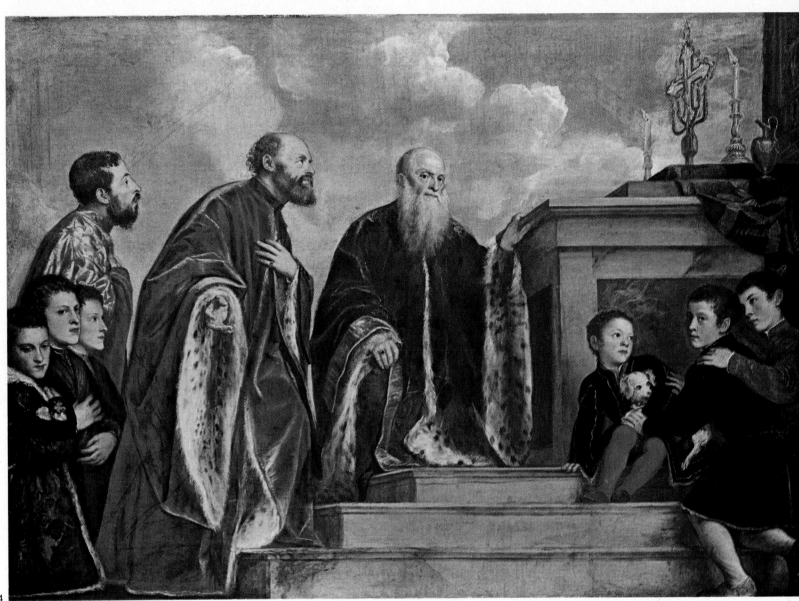

24

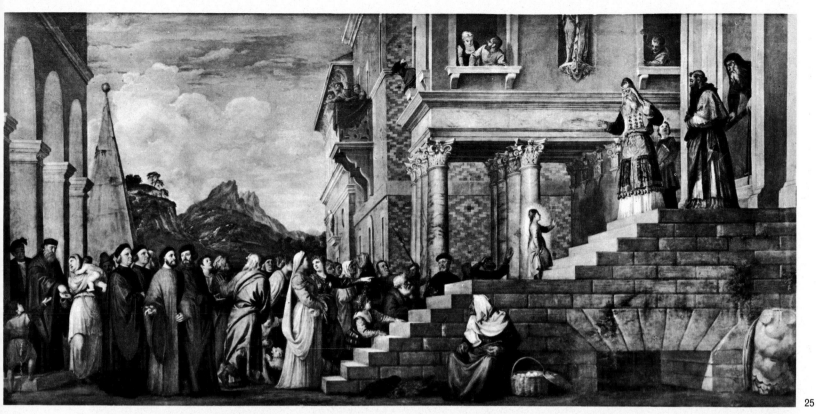

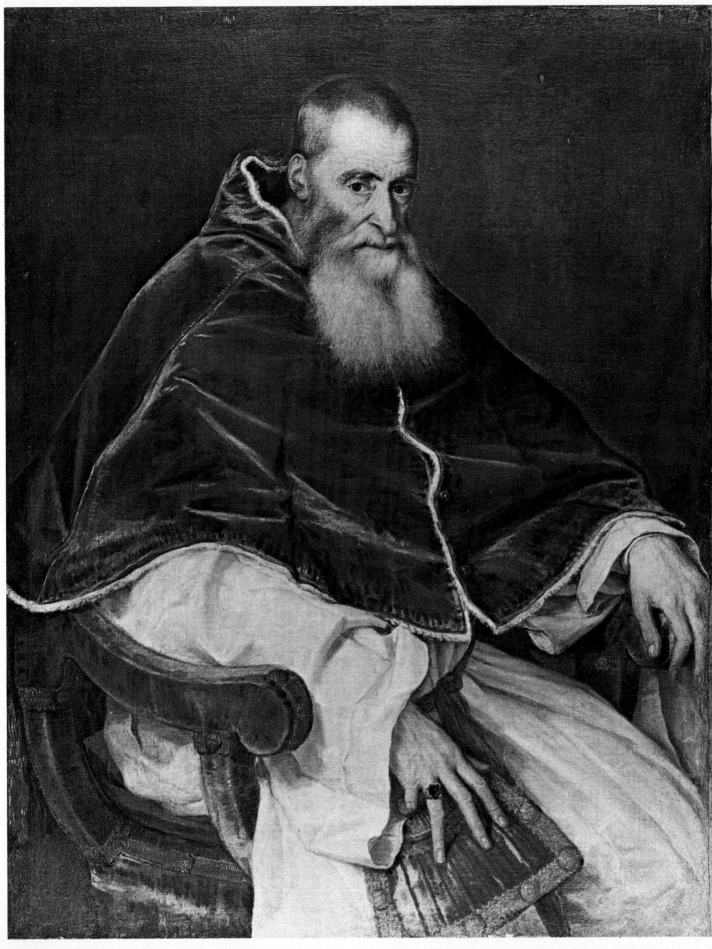

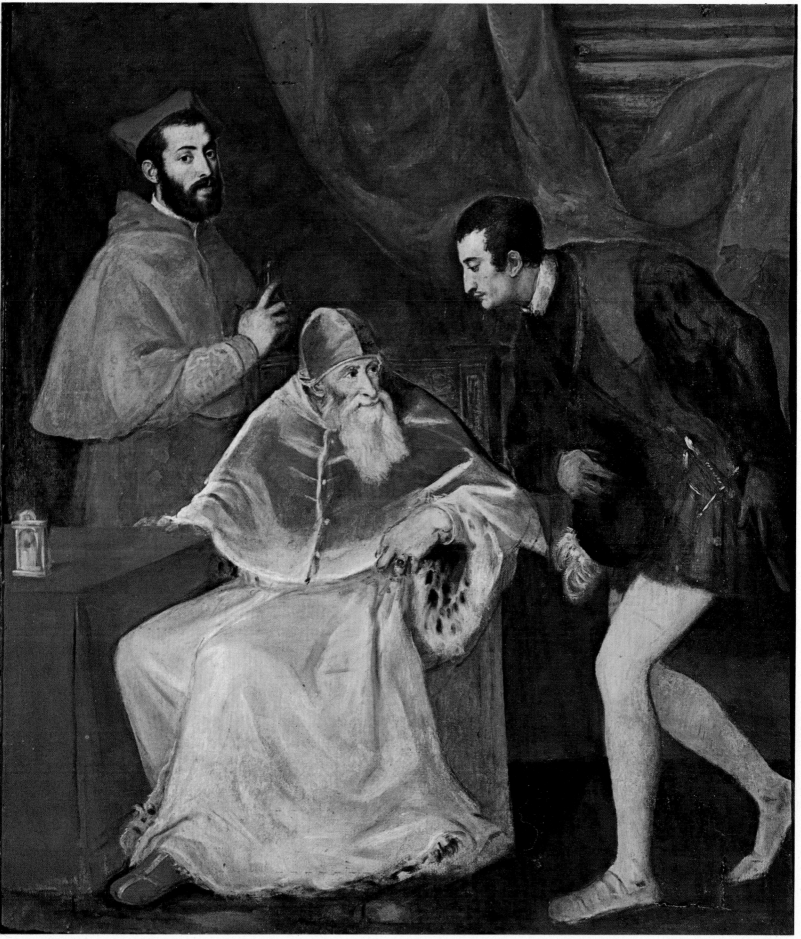

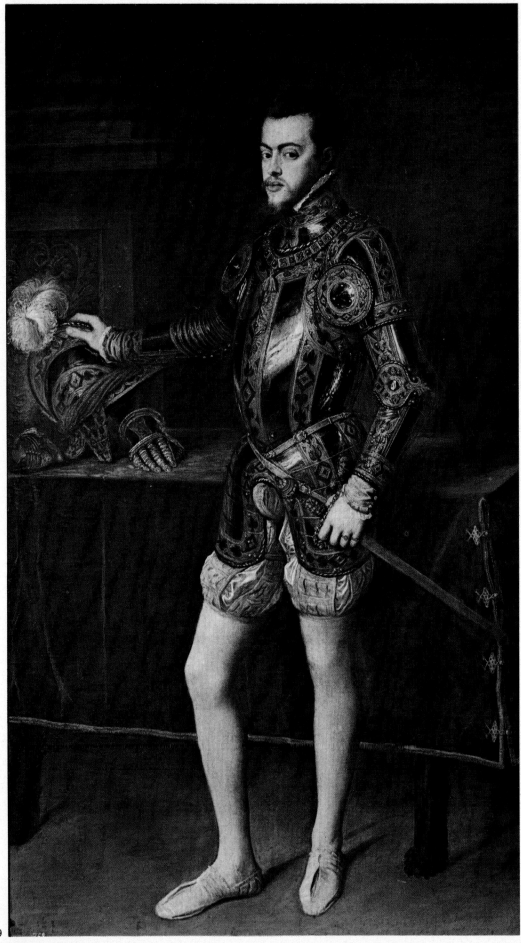

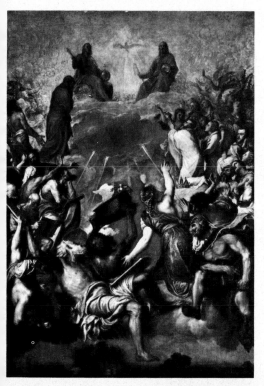

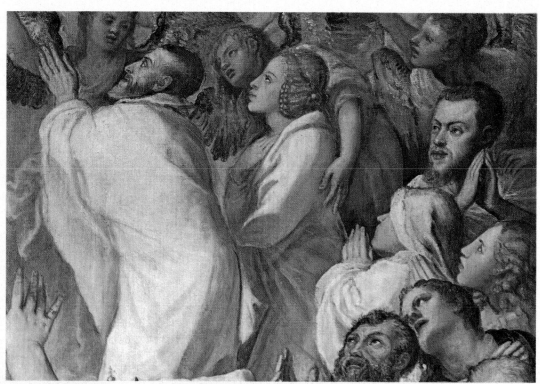

31

32

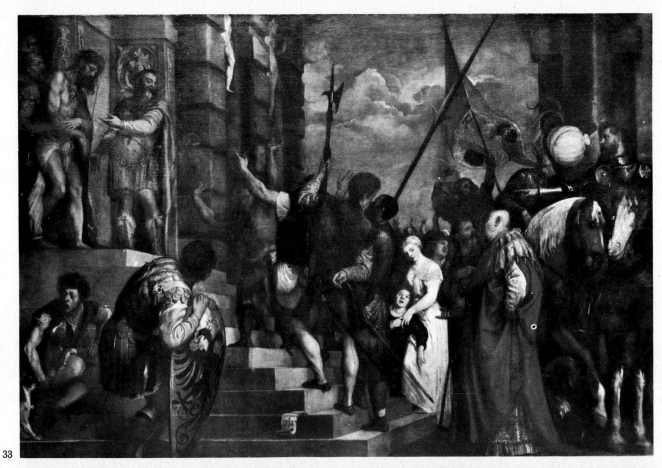

33

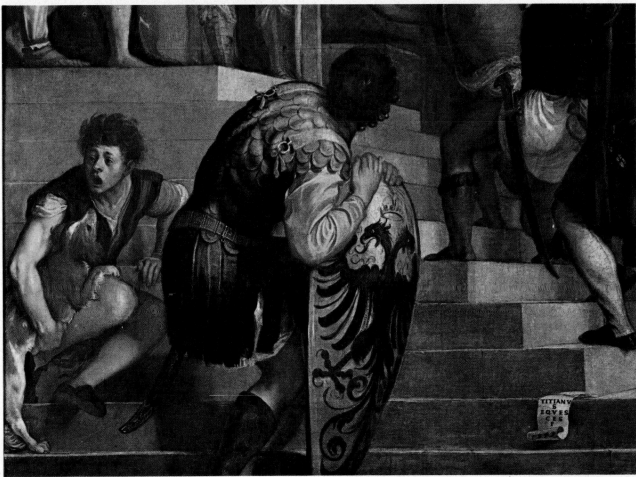

34

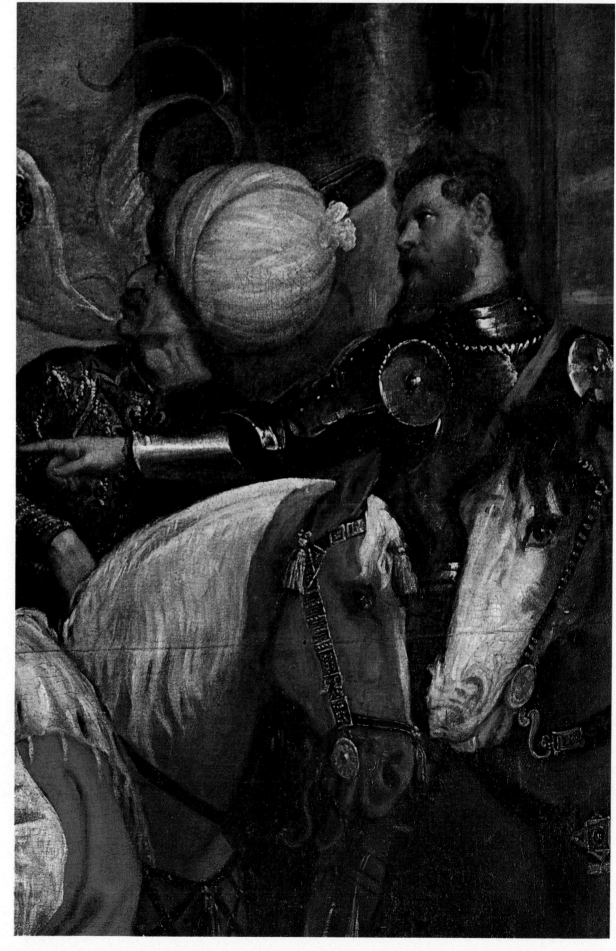

36

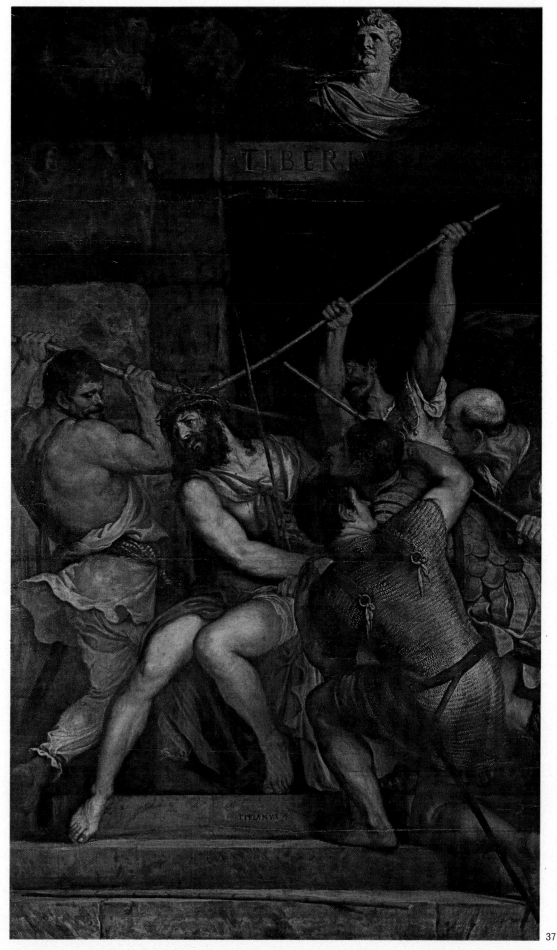

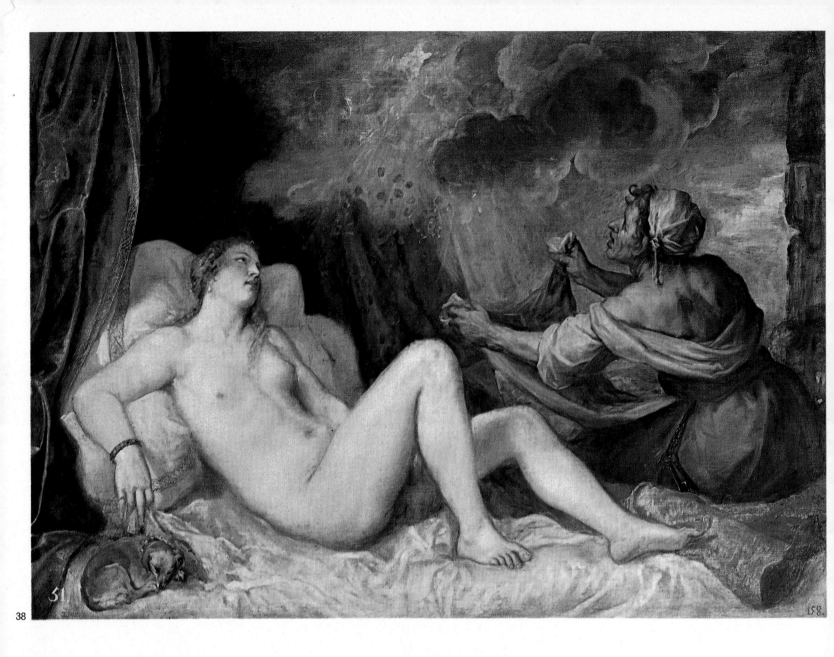

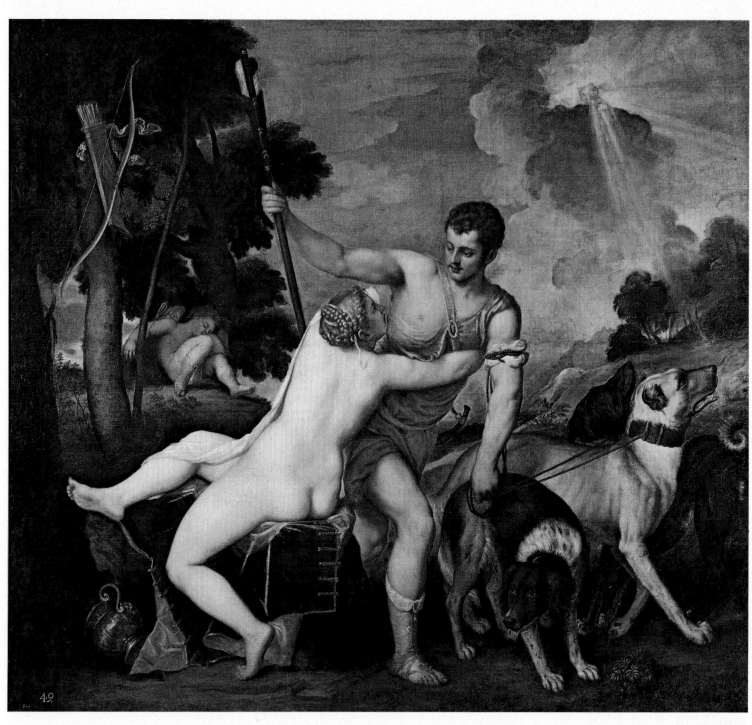

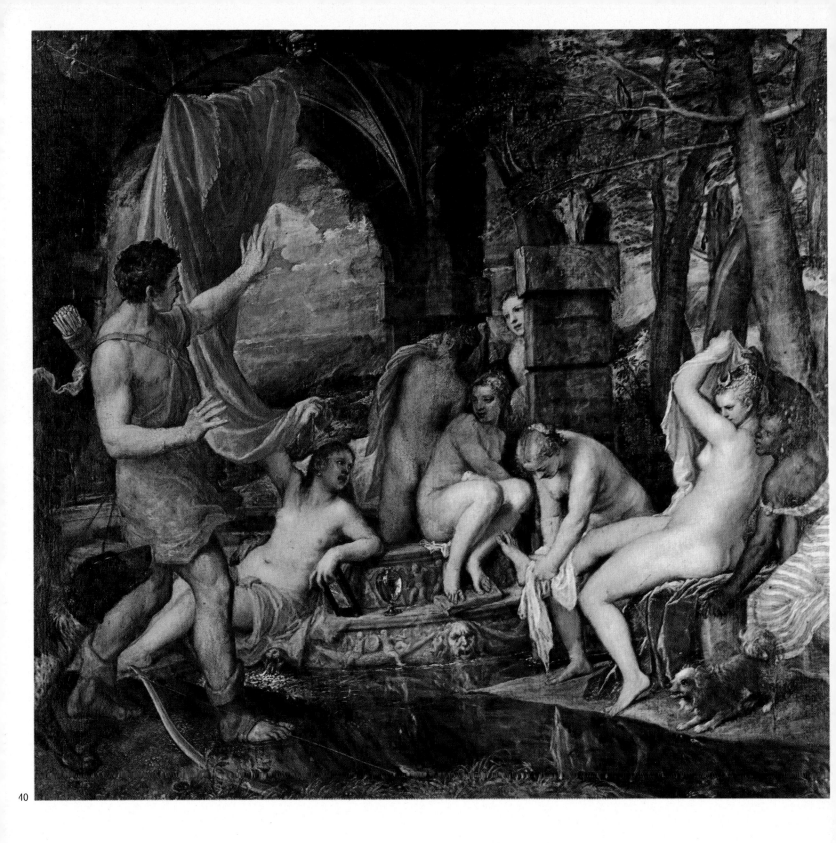

40

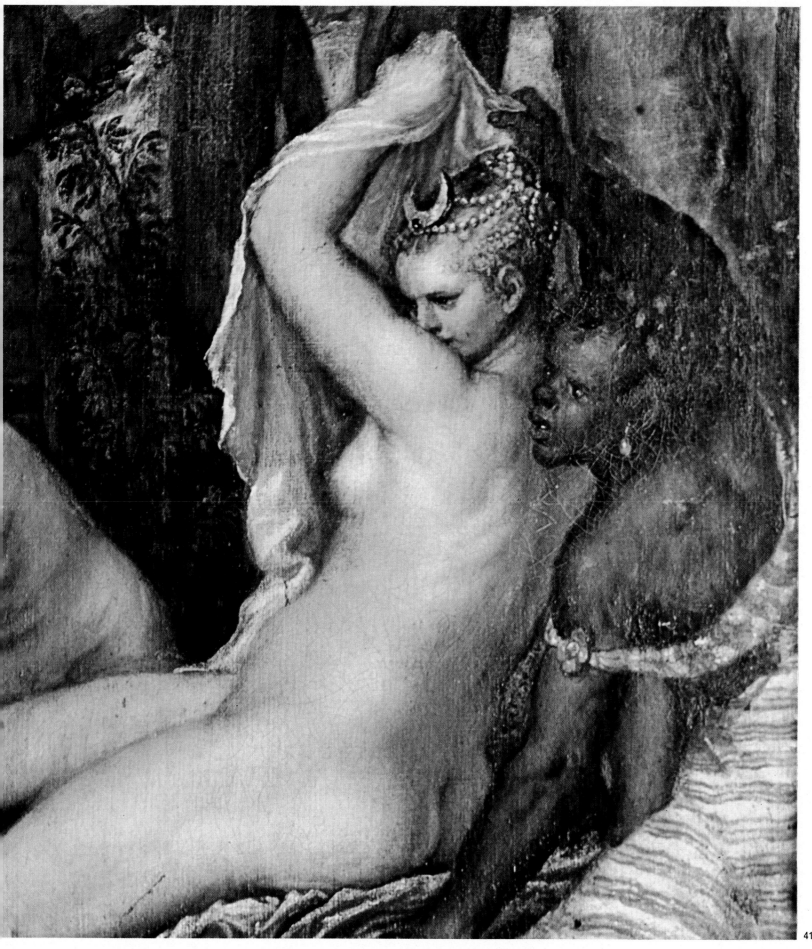

41

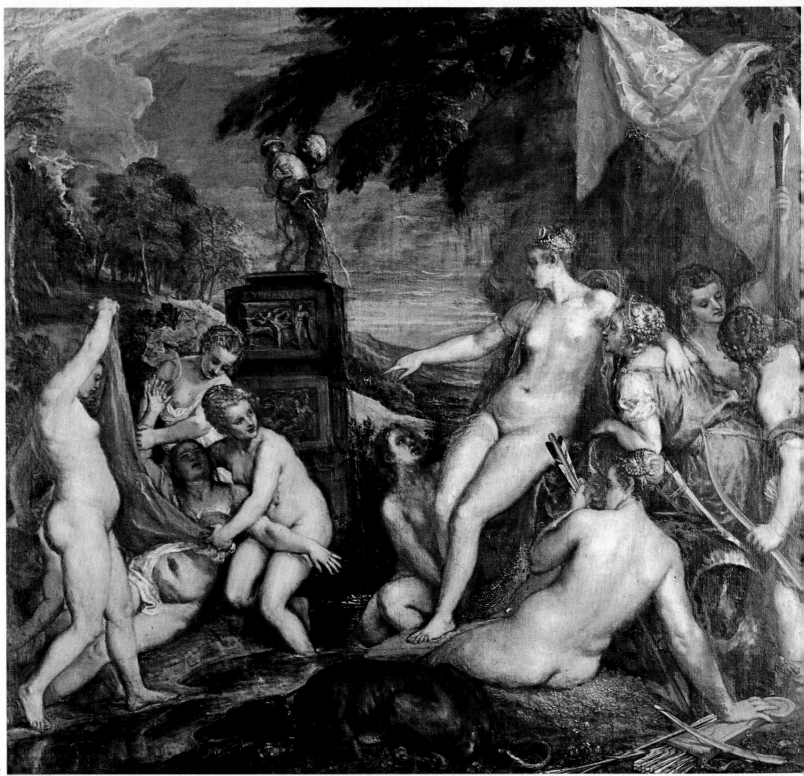

42

43

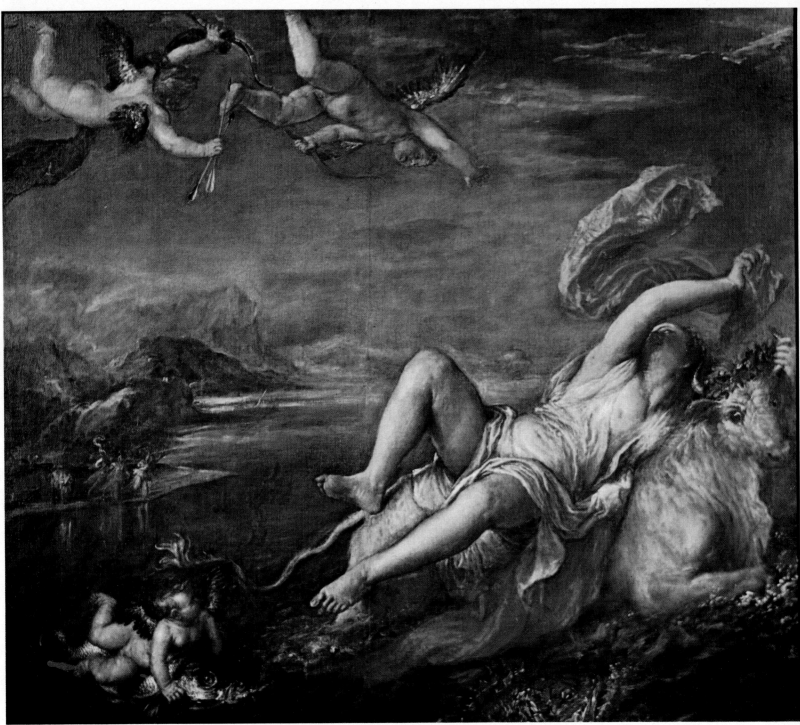

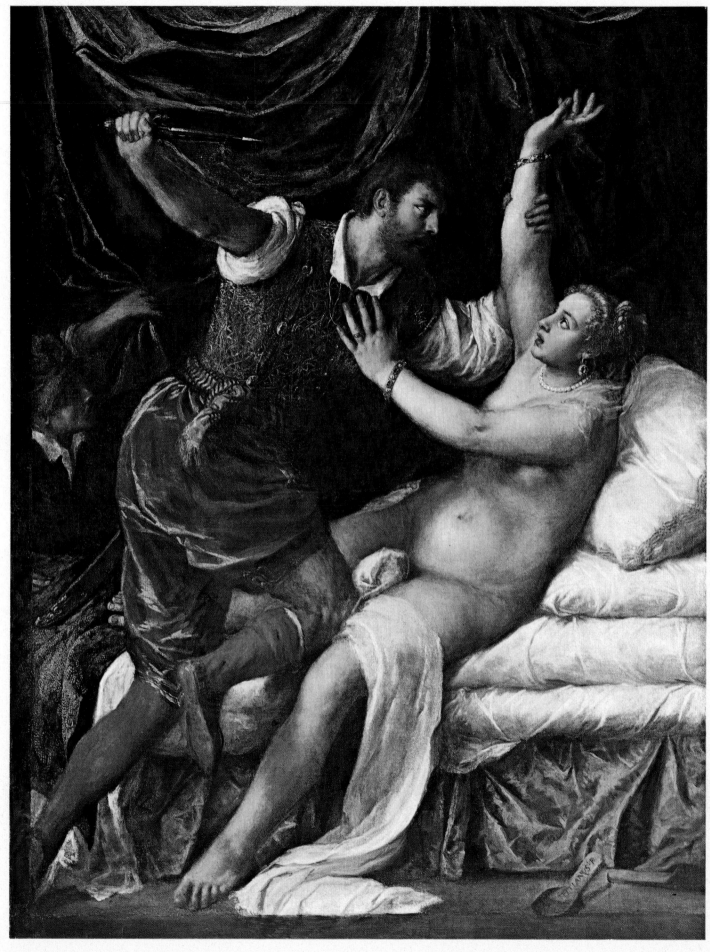

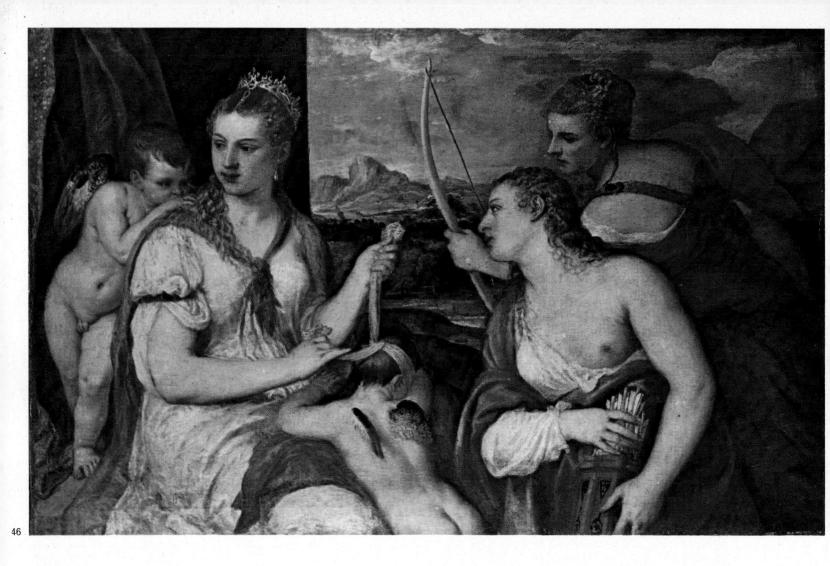

46

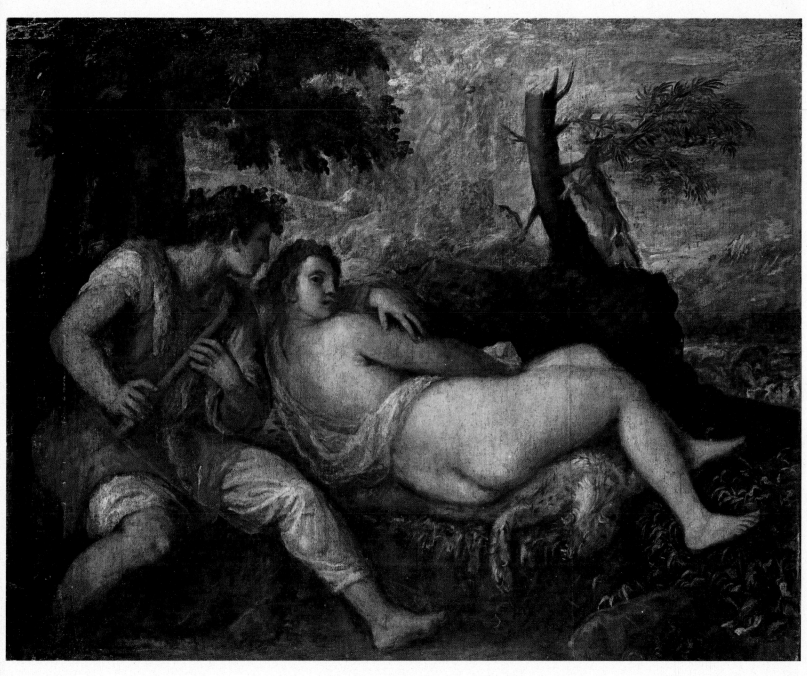

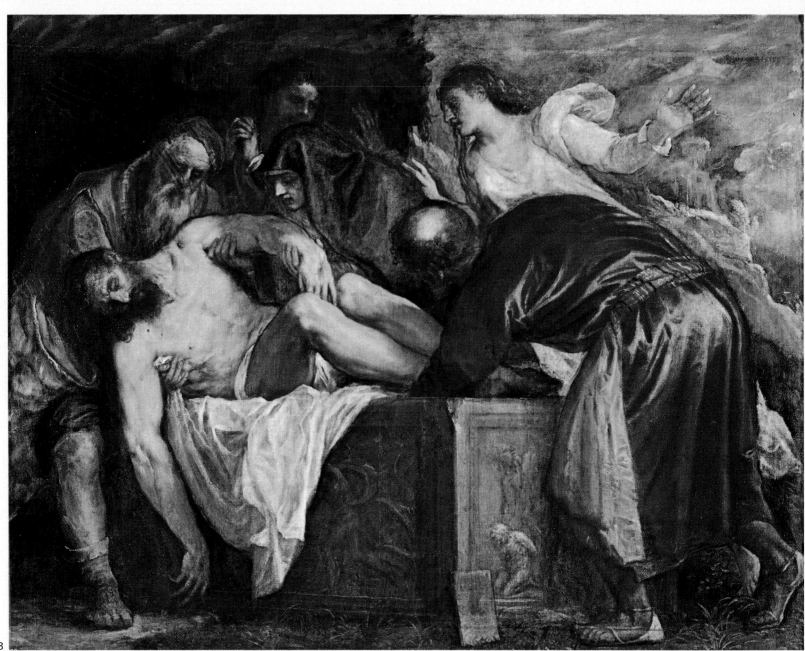

48

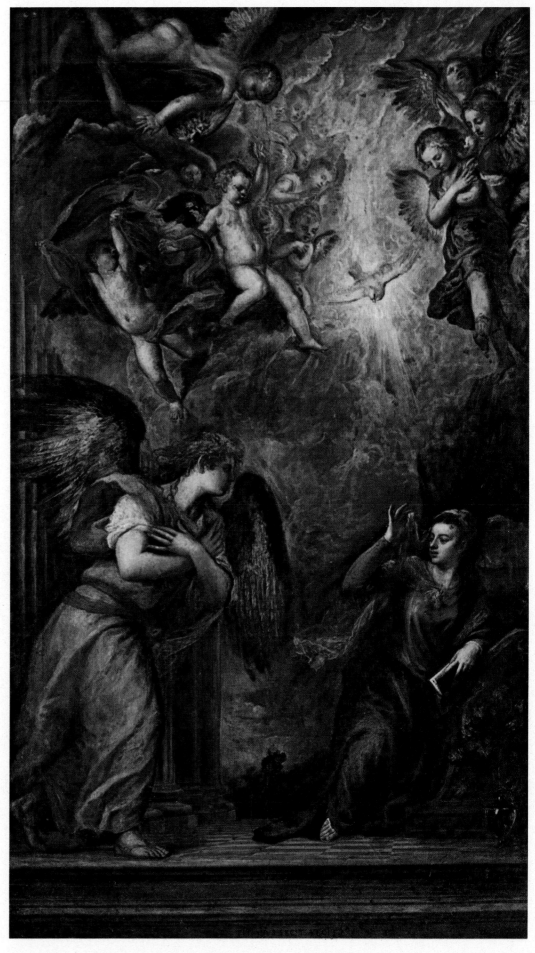

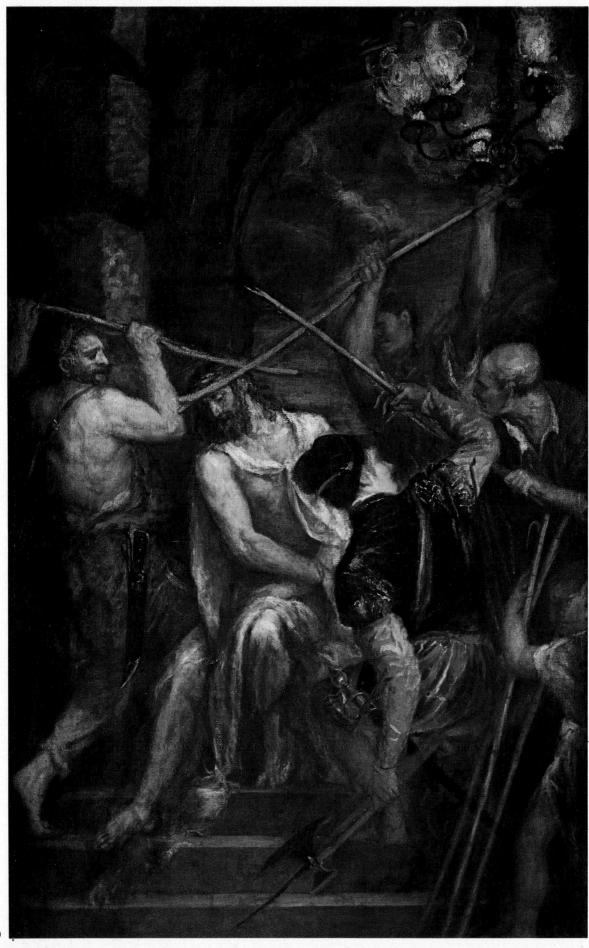

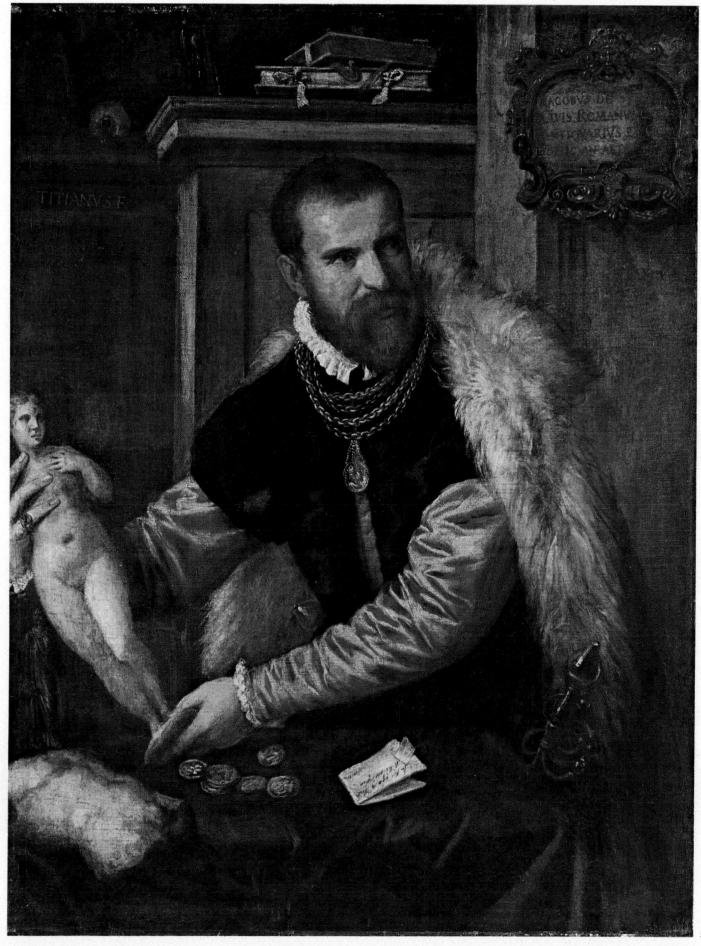

51

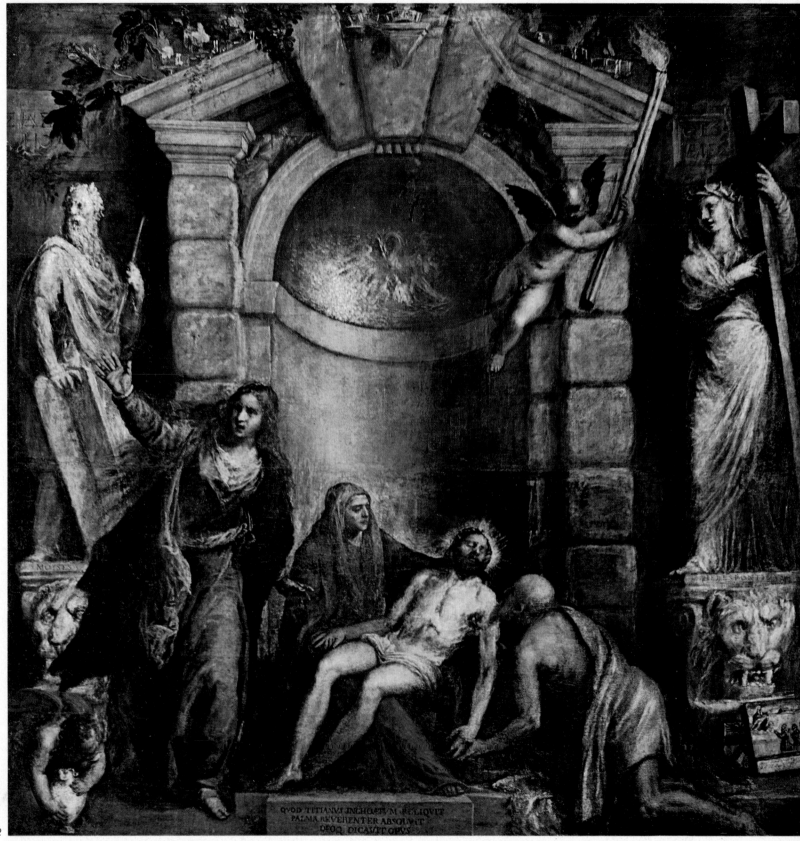

QVOD TITIANVS INCHOATVM RELIQVIT
PALMA REVERENTER ABSOLVIT
DEOQ. DICAVIT OPVS

52